Design in Context

A Framework for Strategic Differentiation

Todd Bracher

A Note to the Reader

6. A Note to the Reader

Over two decades of experience working closely with business leaders, partnering with private equity operators, and collaborating within the venture capital ecosystem, I've had the privilege of engaging with organizations from startups to iconic global brands. My journey has been fueled by a profound passion for innovation and a commitment to bringing transformative solutions to life.

This book is a reflection of my desire to share the insights I've learned along the way, especially the transformative impact that design expertise can have on companies and the marketplace when executed with precision and care.

My work at the intersection of design and strategic leadership has allowed me to witness firsthand the remarkable changes that can occur when these two forces align. As someone who operates at this nexus, I bring a hybrid perspective that not only participates in but also leads the creation of brand-defining and market-shifting solutions. I not only advise businesses but also actively shape their futures, leveraging design as a fundamental tool for innovation and growth.

As the father of two young boys, my drive extends beyond professional achievements. I'm motivated by the vision of contributing to a world they and their generation will inherit—a world where excellence and innovation create a positive ripple effect, benefiting everyone. This book aims to inspire fellow business leaders to join me in harnessing the power of design and strategic thinking, not just for the success of their companies but as a contribution to a better world for all.

Over my career, I've observed common patterns of fear, blind spots, and paralysis that frequently lead companies adrift, regardless of their size and despite best intentions. These patterns often present themselves in the questions I hear clients asking:

What is the best way to differentiate my product or service from the competition?

How can we innovate to maintain a competitive edge in a rapidly changing market?

What strategies can we implement to ensure sustainable growth and resilience against economic fluctuations?

In what ways can we enhance our adaptability to respond quickly to consumer demands and technological advancements?

How can we modernize our offerings without compromising our brand's authenticity?

8. A Note to the Reader

If you're grappling with questions like these, know that you're in good company. Also, know that these questions are not dilemmas; they're signals to explore the potential of your business and indications of areas that merit closer inspection. This book is designed to guide you through these questions, infusing your strategy with innovative thinking and design excellence. By acknowledging the hurdles you're facing and choosing to engage with them courageously, you're setting the stage for significant breakthroughs and rewards. This journey may be challenging, but rest assured, it will be worth it.

Todd Bracher
New York City, 2024

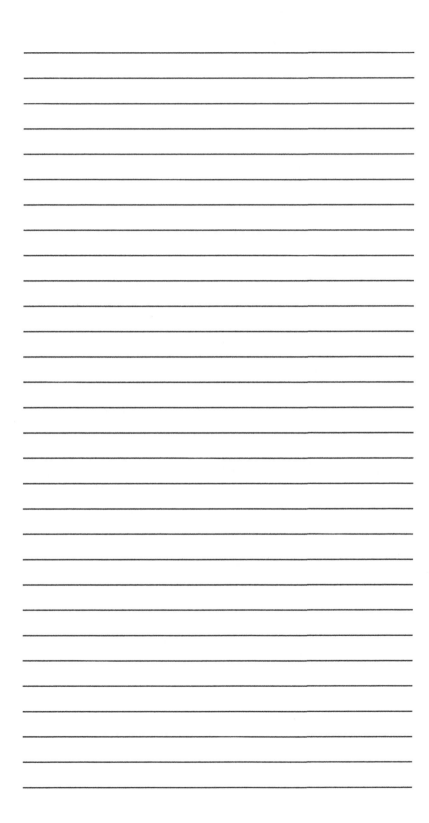

Design in Context

A Framework for Strategic Differentiation

i.

Design as Expertise

18. Design as Expertise

Before delving into how design can be leveraged, it is important to clarify what I mean when I use the terms *design* and *designer*. An aligned understanding of these terms is necessary to successfully apply the practices and insights shared in the subsequent chapters of this book.

Expertise not only amplifies opportunities; it fundamentally transforms them. Recognizing and leveraging expertise begins with understanding the nuanced distinction between a vendor and an expert. This differentiation is crucial in many professional fields, yet it takes on a unique significance in the realm of design.

Typically, one wouldn't visit a doctor, describe a symptom, and demand a specific prescription without a proper diagnosis. People trust doctors to use their expertise to diagnose the issue and suggest an appropriate solution or offer a referral to a specialist. However, the dynamic often shifts when it comes to engaging with design professionals. The prevailing approach tends to categorize designers not as expert practitioners—those who possess the specialized knowledge needed to diagnose problems and offer solutions—but rather as vendors, essentially as suppliers of predefined wants and needs. This perspective significantly underutilizes the potential that designers, particularly those I refer to as *contextual designers*, offer.

Contextual Designers

Contextual designers stand apart as expert practitioners who apply design thinking comprehensively, impacting entire organizations, systems, and industries. They possess a deep understanding of how design can be used not just to solve immediate, visible problems but to anticipate and address deeper, systemic challenges. When business leaders and founders perceive designers as vendors, this expertise is overlooked, leading to missed opportunities. After all, if you engage a designer but assume you've already diagnosed your challenge and simply need someone to implement a preconceived solution, you preempt the possibility of accessing the full spectrum of insights and innovations expert designers offer. This approach risks arriving at a superficial solution and may overlook the root cause of the challenge at hand.

Working with a contextual designer means embracing a partnership where evidence and deep domain knowledge shape your every move. It is about ensuring your business strategy transcends subjective opinions and is guided by objective truths, ensuring that any actions you take lead to solutions that are both creative and aligned with your organization's broader goals.

The essence of design expertise is its capacity to uncover and articulate objective truths.

—TB

Objective Truths

The essence of design expertise is its capacity to uncover and articulate objective truths, utilizing factual data and empirical evidence as the foundation for crafting strategies that drive meaningful change. In choosing to collaborate with contextual designers, leaders empower their organizations with insights and innovations capable of setting new benchmarks in their industries. These partnerships transcend mere problem-solving. They are an opportunity to envision new possibilities, with every decision deeply rooted in an empirical understanding of the context, market dynamics, and specific challenges currently facing the business.

 Embracing design as expertise also requires a shift in perspective from seeing design as a service to be procured to understanding it as a strategic collaboration that can fundamentally enhance the way businesses operate and engage with their markets. It's about recognizing the transformative power of design when applied with depth and foresight. It is a call to leaders to elevate their engagement with design beyond the transactional. This approach strategically positions organizations for sustained innovation and success, anchored in the pursuit of objective truths rather than subjective opinions or political influences.

ii.

Meeting the Need

26. Meeting the Need

The foundation of innovation is anchored in a crucial initial step: a deep and dedicated grasp of meeting market needs. This fundamental approach emphasizes the importance of thoroughly understanding what the market demands, forming the bedrock upon which effective strategies are built. Instead of beginning with a technology looking for a market, successful businesses invert this approach by first identifying the market's needs. This shift in perspective ensures that solutions are not just technologically advanced but are also meaningful, relevant, and needed.

Understanding the Need

The primary goal of "meeting the need" is navigating the complexities of market dynamics. However, to satisfy these needs, a fundamental step must be undertaken: understanding them. Without a nuanced understanding of the problem at hand, there is a risk of missing the mark.

However, the journey to understanding market needs requires more than surface-level observation. It demands an immersion into the consumer psyche, which entails uncovering the layers of desire and necessity that drive purchasing decisions. This process is the absolute foundational element that businesses must get right, as it informs every subsequent decision, from product development to marketing strategy and beyond. In essence, it's the origin point from which all paths to success diverge.

Uncovering the market's true needs is akin to bridging a gap between businesses and their consumers. It requires a blend of empathy, curiosity, and analytical thinking. This is also why businesses must be adept at reading between the lines and interpreting data not just for what it explicitly states but for what it implies about consumer desires and frustrations.

Surveying Internal and External Needs

The journey of meeting needs requires a sophisticated blend of internal and external analysis. Organizations have paramount needs that must be addressed. An inventory of the company's resources, capabilities, and assets, matched against an external landscape that includes market dynamics, competition, and consumer trends, must be carried out. Expertise is necessary to harmonize these factors, ensuring that an organization's strengths are leveraged to address real, pressing, and emerging needs in the marketplace.

This approach also challenges companies to be more than just innovators of technology. It calls on them to be architects of solutions that meet specific needs. The most effective business strategies help

28. Meeting the Need

organizations to align their unique capabilities with market needs. This alignment is crucial for sustainable success, as it ensures that fulfilling external demands also supports the organization's growth, values, and vision. In summary, it's not just about adapting to what the market wants but ensuring that these adaptations harmonize with the organization's core competencies and strategic objectives. Yet, continuous evaluation and adaptation are necessary to maintain this balance. Organizations must remain agile to stay aligned with evolving market demands and internal growth trajectories. This dynamic process ensures long-term relevance and success, fostering a culture of innovation and purpose that benefits both the market and the organization.

The Surprising Nature of True Needs

Embarking on this journey often yields surprising revelations. Sometimes, it even reveals our assumed market need is not aligned with reality. This insight serves as both a hurdle and an opportunity, highlighting the critical need to go beyond assumptions and commit to an authentic discovery process that entails asking the right questions, listening intently, and being willing to pivot based on newfound insights. The market is a complex ecosystem where needs are always evolving and consumer behaviors are constantly shifting. Recognizing and adapting to these changes is crucial to stay ahead of competitors, both known and unknown.

Navigating Disruption by Meeting Needs

Businesses may find that the need they've been serving, with some measure of success, fails to satisfy the market's deeper, underlying demands. This discovery highlights a critical blind spot where potential disruption hides. When companies overlook the deeper demands of their customers, they inadvertently open doors for competitors to introduce more resonant innovations, potentially reshaping the industry and shifting market dynamics.

Understanding the market's needs isn't just about averting disruption; it's about seizing the opportunity to be the disruptor. For this reason, a strategic focus on understanding and meeting market needs does more than safeguard against external disruptors. It cultivates a culture of continuous innovation, ensuring a company remains agile and responsive to evolving market demands. By prioritizing a deep understanding of customer needs, companies can transform potential vulnerabilities into strongholds of growth and disruption.

iii.

Alignment

When integrated strategically, design acts as a guiding North Star, steering an organization's collective efforts toward ambitious, albeit distant, goals.

—TB

Meeting the market need hinges on the critical role of alignment, where key aspects of an organization, from its market strategy to its structural framework, unite in the mission of meeting the need. However, achieving such synergy presents a nuanced challenge far more significant than it may initially appear.

Contemporary organizations often apply a siloed process where ideas are conceived of by one team, developed and tested by another, and finally, marketed by another. This division leads to a significant disconnect between the initial vision and its market presentation, resulting in offerings that are diluted compilations of compromises rather than embodiments of visionary execution. But why settle for delivering products that are merely watered-down outcomes of numerous concessions?

When design takes a central role, the gap between the conception of a solution and its market delivery is bridged, yielding profound results. This central positioning of design transforms the narrative, ensuring that what reaches the consumer is not a compromised product but a realization of a visionary solution.

A Catalyst for Alignment

Often, design is marginalized within organizational structures (i.e., it is seen as a subsidiary function rather than a strategic asset). This underestimation of design's role overlooks the significant impact it can have on an organization's capacity to identify and scale viable concepts effectively. When integrated strategically, design acts as a guiding North Star, steering an organization's collective efforts toward ambitious, albeit distant, goals. Contextual designers, who possess a holistic understanding of a product's or service's requirements, empower organizations to make informed decisions about allocating resources and optimization.

The long-term consequences of sidelining design are also tangible. Analogous to depriving a fire of oxygen, sidelining design can quickly extinguish even the most promising ideas, which comes at a high cost. It likely explains why as many as 75 percent of VC-backed companies never yield a return and why as many as 40 percent of VC-backed companies that raise a minimum of $1 million are eventually forced to liquidate all their assets.[1] Fortunately, there is a brighter path forward.

Research shows that companies valuing design not only boost their revenues but also outperform their peers in shareholder returns. But it's not merely about having a large design team; success lies in elevating design to a top-management concern.[2] The most financially successful companies understand that design's true value extends beyond aesthetics or product functionality—it's about optimizing a product or service to be

36. Alignment

as effective, intuitive, and relevant as possible. In this light, world-class design is not about beautifying a pre-existing product but about rethinking it entirely to ensure maximum market efficacy.

Cross-Functionality

The role of the contextual designer is inherently cross-functional, effectively bridging the gaps between diverse departments, including marketing, sales, development, finance, and legal. This broad scope of involvement provides a panoramic view of the organization, enabling the identification of unique opportunities for innovation, potential bottlenecks, and other strategic advantages essential for a company's growth and efficiency.

Contextual designers have the expertise needed to navigate these specialized domains because they understand the unique challenges and languages of these diverse fields. From navigating the legalities of compliance and intellectual property to grasping the technical challenges of product development and understanding the success metrics of sales, they offer critical insights. Most importantly, these insights empower organizations to predict how changes in design might impact their broader business objectives, streamline operations, and preemptively address legal or logistical challenges.

Furthermore, by having a deep and broad understanding of the various operational, strategic, and market-facing aspects of the business, contextual designers are in a prime position to suggest solutions that are not just imaginative but also practical, feasible, and perfectly aligned with the organization's long-term goals.

This expansive approach to design and business strategy, rooted in cross-functionality, is critical for modern businesses aiming to stay ahead in a competitive and rapidly evolving marketplace. It ensures that innovation is deeply integrated into the fabric of the organization. In doing so, it champions a more cohesive, dynamic, and successful business model.

A Common Language

As cross-functional experts, contextual designers also play another key role in any organization—they provide a common language to help onboard and align stakeholders, ensuring everyone is focused on the organization's strategic vision. Contextual designers possess the ability to discern and internalize what is truly meaningful to each stakeholder. This understanding

38. Alignment

is not just about acknowledging diverse priorities across departments but also about comprehending the underlying motivations, challenges, and aspirations that drive each stakeholder's actions in the organization.

The importance of this nuanced understanding cannot be overstated. By gaining insight into what is genuinely important, the contextual designer can tailor their communication to resonate with all stakeholders. This tailored communication strategy allows designers to articulate the value of design in relation to each stakeholder's concerns and objectives. It's about framing design not just as a functional or aesthetic enhancement but as a strategic tool that directly addresses and supports the goals of different departments, from improvements to market efficacy to strategic differentiation to disruption.

When stakeholders understand how design efforts directly contribute to their department-centric goals and challenges, their engagement and support for these initiatives naturally increase. This alignment, in turn, fosters a collaborative environment and ensures that design initiatives are not pursued in isolation but rather integrated into the broader strategic context of the organization, enhancing their relevance and impact.

Finally, the tailored communication provided by contextual designers plays a vital role in breaking down silos within the organization. In a sense, it facilitates the left hand speaking to the right. By translating design concepts into the language of business, finance, marketing, and other domains, contextual designers facilitate a shared understanding and common purpose. This unity is crucial for the seamless execution of strategic initiatives.

iv.

The Context for Innovation

44. The Context for Innovation

The traditional approach to design, focusing primarily on the object or the "what," often misses the mark in fostering true innovation. Contextual design presents a paradigm shift toward understanding and shaping the "why"—the context within which design takes shape—and it is on this level that it holds the key to unlocking genuine breakthroughs.

Within this defined context, it becomes possible to integrate the market need with organizational capabilities, and the conditions for innovation are most ripe. By defining a context with market need at the center and aligning it with all the variables responsible for meeting the need, a fertile ground for innovation emerges. In short, by focusing on the context, we pave the way for innovations to emerge that are both market and organizationally fit.

Context as an Ecosystem

The foundation of fostering an innovative ecosystem is anchored in the realization that genuine innovation is the product of a meticulously calibrated context. This context transcends the role of a mere backdrop; it is a vibrant framework that critically influences the design journey. It involves a deep dive into understanding market needs, precisely aligning organizational capabilities, and nurturing an environment where these components synergistically interact, yielding results that are not only harmonious but also precisely aligned.

In this ecosystem, every strategic shift, operational constraint, and resource limitation is accounted for, creating a complex tapestry of push-and-pull dynamics that govern the final outcome. The parameters defining this context are intricately linked to the quality of the solutions developed, underlining that innovation is as much about the context in which it flourishes as it is about the creativity it harnesses. This nuanced approach demands that designers and strategists move beyond merely producing singular products or services. Instead, they are tasked with sculpting the conditions that align the market need with the organization.

The ecosystem, by definition, accommodates strategic pivots and operational challenges, integrating them into the fabric of the innovation process. This integration ensures that every decision, no matter how minor it may seem, is evaluated based on its impact on the broader ecosystem. Such a holistic view reinforces the interconnectedness of all business facets, from product development to marketing, from finance to customer service. Each element within this ecosystem doesn't operate in isolation but as part of a dynamic interplay of forces that shape the ultimate outcome—meeting the market's needs effectively.

Genuine innovation is the product
of a meticulously calibrated context.

—TB

By embracing this context-based approach, organizations acknowledge that the fidelity of the context—how well-tuned and responsive it is to both internal and external forces—directly influences the efficacy of the solutions they create. This perspective scrutinizes every decision, ensuring that its contribution to meeting market needs is maximized. Through this comprehensive understanding and strategic orchestration of the ecosystem, businesses can achieve a level of innovation that truly meets and even exceeds the evolving needs of the market.

A Lesson in Contextual Design—The Tree and Its Environment

Consider the natural world as an analogy for this context-based approach. Just as a tree's growth, health, and ultimate survival are deeply influenced by its surrounding ecosystem, so too are products and services by the environments in which they are created. In the diverse realms of nature, from the dense, vibrant canopy of the rainforest to the stark, serene expanses of the boreal forest, trees demonstrate remarkable adaptability. They evolve distinctive features to meet their survival needs, whether it's broad leaves for capturing sunlight in shadow-drenched jungles or needle-like foliage to conserve heat in frigid climates. This natural adaptability underscores the essence of thriving within a given ecosystem by responding to specific environmental cues and challenges.

Translating this analogy to the business world, the "tree"—be it a product, service, or overarching strategy—must similarly be crafted to flourish within the complex "ecosystem" of market demands, organizational structures, and the broader spectrum of external influences. Each variable, from consumer preferences to regulatory landscapes, acts as a factor in the ecosystem, shaping the development and, therefore, survival of the business offering.

Adopting this viewpoint necessitates a significant shift in the role of designers, transforming them from mere creators of objects or services to cultivators of a fertile environment conducive to innovation. Their mission becomes one of nurturing a context that organically supports the growth of solutions that are not only viable but also perfectly attuned to the demands of the market need. This approach emphasizes the importance of understanding the market as a dynamic, evolving entity, much like a living ecosystem. Designers, equipped with this understanding, are better prepared to anticipate shifts and adapt their strategies accordingly, ensuring that the organization's offerings do not just survive but thrive and remain competitive in the face of changing conditions.

This broader, contextual approach empowers designers to integrate a wide array of considerations, from consumer insights and technological

48. The Context for Innovation

trends to economic shifts and competitive actions, into the design process. By doing so, they can create solutions that are not only innovative and effective. In essence, by viewing the solution at the center of a complex ecosystem of meaningful variables, designers can foster conditions where the right solutions naturally emerge, not by opinion but by matter of necessity, securing the organization's relevance and competitive edge in an ever-evolving landscape.

A Lesson in Contextual Design—Darwin's Finches

The story of Darwin's finches serves as a compelling metaphor for adaptation and innovation in the business world. These finches, which evolved on the Galápagos Islands, developed a variety of beak shapes to exploit different food sources across the islands, showcasing nature's ingenuity in adapting to specific ecological niches.[3] Similarly, in the competitive landscape of business, companies must continuously evolve, customizing their strategies and offerings to meet the distinct needs of their market segments.

This evolutionary process in business is not about arbitrarily designing products or services with the hope that they will meet market approval. Instead, it's about carefully shaping the context—understanding the market's underlying needs, preferences, and challenges—to naturally lead to the most effective solutions. In essence, just as Darwin's finches illustrate the power of natural selection and adaptation, businesses can draw on this analogy to navigate their own evolutionary paths, albeit by choice. By focusing on defining the context in which their products and services are developed, businesses can ensure that their innovations are not just well-designed but are precisely aligned with the evolving needs of their markets.

A Lesson in Contextual Design—The Anatomy of a Golf Swing

Ask a passionate amateur golfer what results in the perfect shot, and they will likely be able to list several factors that must be taken into account. Even the amateur knows that stance, grip, choice of club, and the direction of the wind are important variables. But if the amateur is able to list over a dozen variables that matter, the professional golfer can list hundreds of variables, which is why they are able to achieve desired shots, even under wildly varying conditions. Pros also can do more than itemize the variables one should account for when preparing for a shot. They understand how to line everything up to achieve the desired outcome at exactly the right moment.

50. The Context for Innovation

Most of us have experienced the feeling of efficiency in a great swing. However, as an amateur, the joy of aligning your movements with a singular desired outcome is fleeting and sometimes left to chance. By contrast, a professional is able to consistently repeat this experience, even fine-tuning the outcome to make it more predictable over time, no matter what conditions they face on the golf course.

Like golf pros and any other professional athletes, the most experienced designers understand the multitude of variables at work in any given context. They know how to identify these variables and how to line them up to achieve a desired outcome. Ultimately, they know how to make something phenomenal happen and ensure it consistently lands in the right place at precisely the right time. Ironically, this is also why the impact of design is often difficult for people who aren't designers to recognize, understand, or value.

When something looks effortless, it can be difficult to fully grasp the expertise at work. At its best, most design does look effortless. However, it is important to recognize that the best design looks effortless not because it is simple but rather because it is inevitable.

When you design through context, you inevitably arrive at a result with no alternative, and in the process, the work of the designer or design team disappears. When products and services make perfect sense—when they have no alternative, no rivals, and no choice but to exist in the world—there is no reason to contemplate how and why they came to be in the first place.

V.

Variables

In the journey of innovation, understanding the variables that define the context is where the theoretical meets the practical, where ideas transform into impactful realities.

—TB

In the journey of innovation, understanding the variables that define the context is where the theoretical meets the practical, where ideas transform into impactful realities. The richness and depth of these variables play a crucial role in shaping the outcomes of any design or strategy. Just as the ecosystem's myriad factors, including sunlight, soil composition, rainfall, and climate, determine the growth and health of a tree, so too do the variables of any business's context influence the success and efficacy of its outcomes.

Governing Variables

It is critical to understand the intricate interplay of variables and their direct impact on the quality and efficacy of one's results. In the natural world, the diverse beak shapes of Darwin's finches didn't arise in a vacuum. They are the product of countless environmental variables, each contributing to the birds' evolution to exploit different ecological niches effectively. Similarly, the business landscape is shaped by a complex web of variables, from market trends and consumer behaviors to technological advancements and operational limitations.

Fidelity's Causal Relationship with Efficacy

High fidelity in understanding the variables—meaning a detailed, accurate comprehension—allows for a nuanced grasp of any context. This deep understanding is akin to recognizing not just that a tree requires sunlight but also understanding how the intensity and duration of exposure to sunlight will influence its growth. In golf, the professional who is able to assimilate a wider array of factors into any shot than the amateur also demonstrates their advanced expertise through the management of complex variables. In business, it could be the difference between knowing your target market demographically and understanding their behaviors, preferences, and pain points on a granular level. The number and diversity of factors included in the analysis enriches the context and, as a result, enriches the outcome. It's about moving beyond surface-level insights to uncover the rich, intricate layers that ultimately inform the outcome.

Drawing from the analogy of the tree and Darwin's finches, it becomes clear that the variables that define their ecosystems—be it sunlight, soil chemistry, or specific ecological niches—directly correlate with growth, health, and evolutionary success. Similarly, in the business realm, understanding and integrating the vast array of variables that influence

58. Variables

the market and organizational capabilities allow for the cultivation of solutions that are inherently suited to thrive in their intended environments. This careful attention to the variables defining the context is what ultimately enables businesses to meet their strategic objectives.

vi.

Efficiency of Outcomes

An imbalance, whether through excess
or deficiency, can skew the intended outcome
of a strategy or design, much like the
delicate equilibrium of a chemical compound.

—TB

In the pursuit of innovation, the journey to understanding a successful interplay of variables within a given context is akin to appreciating the precise chemical composition that defines water. H_2O, a seemingly simple molecule composed of two hydrogen atoms bonded to a single oxygen atom, is a demonstration of nature's intricate efficiency. The exactness of this configuration imparts distinctive characteristics to water—characteristics that are critical to its role in life on Earth and would be irrevocably changed with the addition or removal of any component. Introducing an extra oxygen atom, thereby creating hydrogen peroxide (H_2O_2), doesn't merely modify water; it fundamentally alters its properties and applications. Something that was drinkable becomes toxic through the introduction of one additional atom. This analogy extends to the realm of business innovation. An imbalance, whether through excess or deficiency, can skew the intended outcome of a strategy or design, much like the delicate equilibrium of a chemical compound.

Nothing Extra, Nothing Less

This principle of "nothing extra, nothing less" is not confined to simple molecules but extends to even the most complex compounds in chemistry. Take, for example, the molecule of DNA. Its complex structure, a double helix formed by long chains of nucleotides, is meticulously organized. Each component of DNA is essential for its function of encoding genetic information. Adding or removing a single nucleotide can lead to mutations, altering an organism's genetic blueprint. Yet, this complexity adheres to the same principles of efficiency and necessity as the simple water molecule. Every element within the DNA molecule plays a critical role, and the balance achieved is what allows it to successfully carry out its function.

Drawing from these analogies, the process of designing solutions within a business context mirrors the precision seen in chemical compositions. Just as the water molecule requires a specific arrangement of hydrogen and oxygen to exist as water, and DNA demands a precise sequence of nucleotides to function, so too does the innovative ecosystem demand a balanced integration of variables. This balance ensures that every component of the strategy or design is essential, with nothing superfluous detracting from the outcome's efficacy.

Achieving this balance—where the system is optimized, and the outcome naturally emerges as the best solution—signals that the desired outcome has been reached. It is a testament to the efficiency of the design process, ensuring that the solution is not only effective but perfectly attuned to the needs it aims to satisfy. This "nothing extra, nothing less"

approach is what enables businesses to craft solutions that are as elegant and effective as the natural systems that inspire them, ensuring that they meet their strategic objectives with precision and success.

Outcomes

In navigating the complex journey of innovation and strategic development, the process outlined in this essay serves as a framework for eliminating conjecture, overcoming fear, and dispelling indecision. This methodology is crafted not merely as a procedural guide but as a transformative approach designed to equip businesses with deep insights and deliberate intention. Its core aim is to sift through the noise of subjective opinions and to anchor decisions in the bedrock of objective understanding.

This process champions aligning all stakeholders—each department, team, and individual—toward a singular, well-defined outcome calibrated to meet market needs as perfectly as possible. It's about marshaling collective efforts and resources in a direction that's not only strategically sound but also tailored to the unique demands of the market and the intrinsic capabilities of the organization. By doing so, it assures that the resulting outcome is not a product of happenstance but deliberate creation optimized to thrive in its intended context.

Such an outcome stands as a testament to what can be achieved when a business moves with insight and intention. It represents a solution fit for the market. Simultaneously, it represents a solution fit for the organization—leveraging its unique strengths, navigating its limitations, and advancing its overarching strategic objectives. Most crucially, this outcome achieves a harmonious balance, matched to its context, ensuring its viability, sustainability, and efficacy.

Ultimately, *Design in Context* is a framework that empowers businesses to act decisively and with confidence. It's about forging a path forward that is clear, intentional, and grounded in the reality of the market and the organization's place within it. Through this, businesses can transcend the paralysis of uncertainty and move forward fully aligned and strategically positioned to achieve their precise, contextually aware outcomes.

11.21 am

8.21 am

12.42 pm

4.38 pm

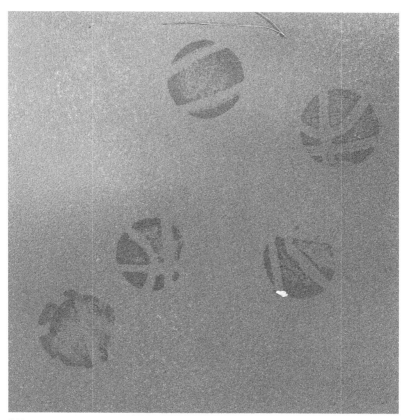

7.10 am

Innovation comes from questioning the status quo, exploring the unasked questions, and daring to reimagine the everyday.

—TB

11.10 am

3.32 pm

11.50 am

5.15 pm

2.34 pm

11.37 am

Design is not an abstract process.

—TB

5.11 pm

4.40 pm

11.18 am

3.52 pm

4.23 pm

10.24 am

6.10 pm

A great idea is often the easy part: guiding it to meet the market with clarity and relevance is the work of great design.

—TB

5.13 pm

11.21 am

11.29 am

8.14 am

Design the context meticulously, and the optimal solution becomes inevitable.

—TB

11.17 am

4.36 pm

10.17 am

4.49 pm

8.14 am

12.06 pm

When two trees differ in appearance, we attribute their uniqueness to the influence of their respective ecosystems.

—TB

4.11 pm

3.27 pm

1.41 pm

11.12 am

2.14 pm

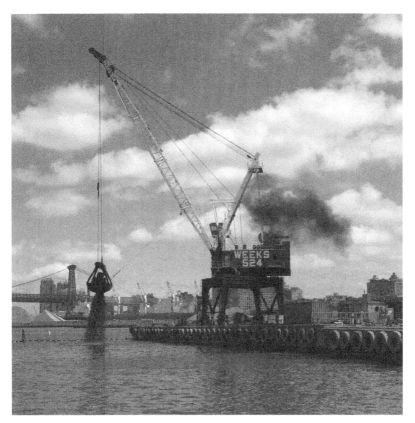

9.10 am

Good design achieves the efficiency and precision of mathematics.

—TB

9.52 pm

9.37 am

10.26 am

5.12 pm

7.14 pm

1.41 pm

Many of the world's greatest challenges already have solutions; it is often humanity itself that stands in the way.

—TB

11.17 am

11.22 am

1.41 pm

9.02 am

5.23 pm

12.21 pm

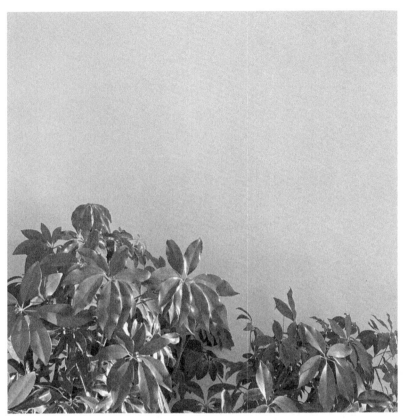

5.19 pm

Design must never be a matter of opinion.

—TB

4.13 pm

10.15 am

4.37 pm

10.22 am

True beauty in design emerges when every detail serves a purpose, creating harmony between form and function.

—TB

3.45 pm

4.24 pm

10.17 am

10.48 pm

10.11 am

11.15 am

Good design transcends opinion; it is a lens of insight aligning true user needs with an organization's capabilities.

—TB

12.41 am

10.13 am

1.41 pm

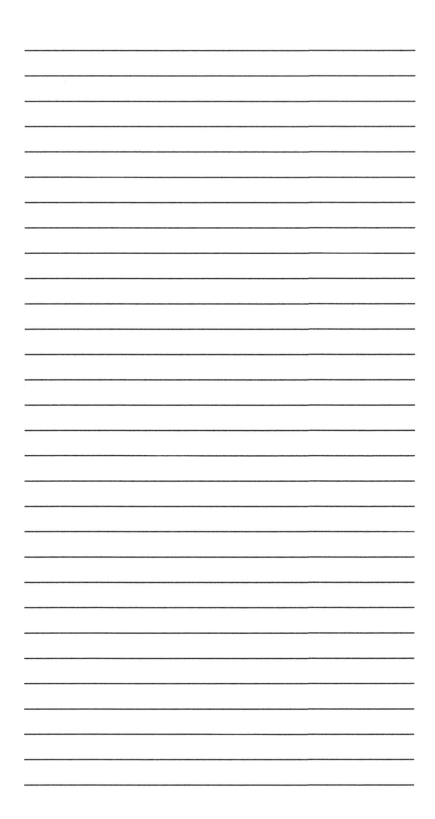

Dialogues

i.

Michael Bierut

Design as Business

Michael Bierut studied graphic design at the University of Cincinnati's College of Design, Architecture, Art, and Planning and spent ten years at Vignelli Associates before joining Pentagram as a partner in 1990. Based in New York, London, and Berlin, Pentagram is one of the world's most well-known independent design studios. As a partner at Pentagram, Bierut has served clients including, among many others, The New York Times, MIT Media Lab, Mastercard, Princeton University, the New York Jets, and the Brooklyn Academy of Music. As a volunteer, he also designed Hilary Clinton's H logo, which became ubiquitous in her 2016 presidential campaign. Bierut served as president of the New York Chapter of the American Institute of Graphic Arts (AIGA) from 1988 to 1990 and is president emeritus of AIGA National. He also serves on the boards of the Architectural League of New York and the Library of America. Bierut is a senior critic in graphic design at the Yale School of Art and a lecturer in the practice of design and management at the Yale School of Management. His books include Seventy-nine Short Essays on Design, *published by Princeton Architectural Press.*

154. Design as Business

Michael Bierut: When you were growing up, did you have any favorite objects? Things that you remember looking at and loving?

Todd Bracher: Yeah, I think for me, probably, my favorite objects were model airplanes.

MB: Oh, really?

TB: With my brother, we'd build model airplanes.

MB: What did you like about that?

TB: He always wanted to fly, and I always wanted to build. And, ironically, he became a Navy pilot.

MB: Are you kidding me? And you became a product designer!

TB: That's right. With model planes, there's something beautiful about how every part has a purpose. The scale, even, was interesting because you would somehow miniaturize yourself to experience this beautiful little object—the three-dimensionality of it. It's something you hold in your hand, and yet it offers an understanding of the inside and outside of how these machines work. What is interesting is that for me, these model planes were beautiful objects, and for my brother, it was what you can do with the object.

MB: Was there a moment when you realized that you could, in effect, build model airplanes for a living? Did you understand that it was a profession that had a name or that industrial design existed as a field of study?

TB: In some ways, I never thought about it. I just continued on a path, one foot after the next. My father also was a cabinet maker and a carpenter. So, building things seemed quite normal to us. But I discovered industrial design when applying to design school actually. Part of the entry was to create a breathing device, and I remember thinking it was an illustration exam. But I did the exam thinking, okay, I did the drawing, but now I wanted to design the respirator. I realized that this was really interesting because it combined science, physics, and fashion. It combined all these aspects of our life and our world. That's when I realized what this was called and discovered industrial design.

MB: And that was at Pratt?

TB: That's right, at Pratt.

Design is very poetic,
very human-centered, and very beautiful.

—TB

MB: But after you graduated, you went to Copenhagen, right?

TB: That's right. After Pratt, I spent a few years working in New York City designing consumer products, which were not at all aligned with what I thought design was. Design is very poetic, very human-centered, and very beautiful. Instead, we were doing very commoditized product design. So, I applied for a Fulbright and was lucky enough to get an opportunity to go to Copenhagen. I spent two and a half years there doing a master's course in interior design and furniture design.

MB: And what do you think the main learning you got from studying design in Denmark was?

TB: Denmark was just a place I fell in love with immediately. The culture was very different from what I grew up with as a New Yorker. It was very much about being human, understanding your environment or weather, and being connected to the environment, in fact. And, so for me, I saw a real connection there and an honesty in design—a real appreciation for material, color, how it affects your life, how it lives in your life, and not just as objects in your life.

MB: I know that you went on to work in Italy, France, and England. Did you find that each of those contexts sort of gave you a different perspective on what design could be?

TB: Absolutely. After I left Copenhagen, I moved to Milan, where I started to work. I worked part-time but also started to sell my own designs. And spending time in the culture was fascinating to me. I eventually moved to Paris and onto London and then back, almost ten years later, to New York. Having this sort of journey of these five countries was so important. Each sort of cultural experience gave me something unique. And I would say that in Denmark, honestly, what I gained was simply being there. In Milan, it was very much about poetry, understanding how to communicate a story through an object in a very simple way. And then, in France, it was very much about the elegance—the elegance of the material. When I was in London, it was very much about individuality. I was working for a very famous designer—there is a real focus on the identities of individuals and design in the UK. Then, when I moved back to the US, it was very much about business and the marketing of design. In the United States, when you think about design, you think about Apple computers, Coca-Cola, and these incredible brands. The combination of these five experiences and five cultures really helps define how I look at design today.

Honesty in design does make us feel better.
It's about transparency.

—TB

MB: And do you think those five can be reconciled? It seems like honesty and poetry maybe don't go together. Honesty and marketing certainly don't go together.

TB: Well, I think they do, actually. I really think they do. For me, there's an honesty in materials. So, I don't like to paint wood, for example. I think it's a strange thing to do. Use plastic or a composite material if you need it to not be wood, so to speak. So effectively, I've cherry-picked from these cultures to assimilate a way of design that is more human and speaks to us in a way that's relevant to our culture.

MB: Do you think, though, honesty in design makes you feel better as a user?

TB: I think honesty in design does make us feel better. It's about transparency. As a designer, I think I'm trying to translate this honesty to you. And I think that's inherently connecting you to the experience. I'm not trying to manipulate you. I'm not trying to deceive you. I think it's very much about understanding you, being empathetic to you and your experience, and for me to deliver the sort of envelope for you to have a truthful experience.

MB: When you established your studio here in the United States, in Brooklyn, I think, what was the first product you did?

TB: The first product I did when I first came back to the United States was something that couldn't be done in Europe. It's actually a chair for a new way of working. And very different from how life was in Europe.

MB: Explain why.

TB: So, in Europe, you'd design it in April, and then it's manufactured and launched the following April. So, it's usually a one-year lifecycle, which means it's quite easy to build. That's where the honesty applies because the material is going to be what it should be. The poetry is very clear because it has to be a good idea and a beautiful idea. In the United States, it's very much about, you know, now we're cutting tools. It's much more investment-heavy because the market is larger. We're trying to serve a larger opportunity. In this case, the chair was for Humanscale.

There was now an understanding that folks were starting to work a bit differently and not just in the workstations and next to computer terminals. People were now out in the workplace and in the softer zones, I like to call it, and in what we now call collaborative areas. So, we wanted to bring the

level of ergonomics and comfort that you get when you sit at a computer but beyond the experience of sitting in front of a computer. So, you have proper ergonomics, but we did that in a way that doesn't look like a tool or a typical task chair.

This type of thinking is not typical in the European side of business. But ultimately, in the US, we were thinking that's exactly what the market needs for that space, and there's a big market for it.

MB: Was it the client that sensed that need? Was it you who sensed that need? How did you identify that that was an opportunity?

TB: A lot of our opportunities emerge because we're very connected to the end users. In this case, we are also end users. So, the other side of where our opportunities come from is from frustration.

MB: Frustration as a driver for design.

TB: In some cases, there is clear visibility—I would never use this, and I don't know who would. And then we, of course, go out there and try to find out if we are alone in this thinking. And we very quickly discover we're not. We're part of a contemporary culture, and so is the audience we're speaking to. So, what we're doing is responding directly to this bond throughout our culture. And opportunities, for us, a lot of the time, aren't very difficult. We see them. They're very clear. They're very evident. But it isn't always immediately evident to our client. Our client is typically removed from understanding the culture they're serving. So, it's up to us as designers to champion the end user.

MB: How would a chair designed for collaborative work look different from a chair designed for just sitting at a desk or at a computer?

TB: The workplace itself has evolved quite significantly. But if you even just take the last ten years or so, thanks to iPads and iPhones and mobile devices, you're now less tethered to the desktop. So, now we're able to roam throughout the workplace, and by the way, the younger generation want to roam around the workplace. We don't want to be chained to a desk, so to speak. That's now providing new modes of work throughout the work zone. When you now do a walkthrough, you'll see that folks are working with soft seating, they're not working in front of a computer at a task chair. So these chairs are much more comfortable now. They're designed to almost look like they've come from your home. But now, I believe the design needs to address that properly. So we're not just taking a sofa from your home and putting it in the workplace and asking you to sit

on that now for six hours. There needs to be proper design around these types of furniture that will support the new modes of work.

MB: And did this take more than a year, unlike Europe? April to April.

TB: Absolutely.

MB: How long?

TB: Projects like this can range—typically two years, but maybe to four or five years even.

MB: I imagine that a runaway success in Italy, that those figures would barely be a blip in the United States, given the relative size of the markets, right?

TB: That's correct. It would be a blip in terms of financial growth. But in terms of contributing to our culture, it's huge. And I think that's the difference. That's why we like to explore and play on both sides. And we want to be still present, stay present in the European side of business because that's where my heart is in some ways, and that does contribute to our culture as a whole.

MB: You divide your business into product design on one hand and design advisory on the other. How do you define design advisory?

TB: Design advisory, for me, is effectively the lens through which we look to help communicate design. What we do, the way we approach design in my studio, is we try to understand the limitations and the opportunities, the objectives, you name it. We really try to understand all of the aspects which govern the eventual result. And for us, the advisory is clarifying all of these governors. The product design is actually the influenced solution at the end of the day—it is what emerges from this context.

MB: Is it hard to get permission to have those kinds of discussions? I mean, if you're coming in, if someone's authorized to bring in a product designer or industrial designer to help design a product, do they have the ears to hear you when you start talking about these concentric circles that move out from that part of the project?

TB: The way I look at it, my job as a designer is to demystify and take abstraction out of design. When I speak to business owners or other stakeholders, if they don't understand the value of what we can do, I'm

My job as a designer is to demystify
and take abstraction out of design.

—TB

either not communicating properly, or it's just not the right fit. And I think as a business owner, if your designer or the folks you're speaking to in that capacity also don't communicate well to you, you don't have the right designer. So, I do believe understanding and communicating properly are the objectives that have real business value for your audience—in that case, the client.

MB: When you're doing that kind of work, do you use design to advance the conversation? Are you making speculative prototypes and things to say that if you thought this way, this would be the outcome?

TB: In some cases. I subscribe to this idea called context-based design. It comes from chemistry. A good example of this is H_2O. If you add or take a single molecule away, it is no longer H_2O. The same holds true in business. If a business is saying, "We're trying to create a solution," I look for the optimal solution—the most optimized solution that can deliver the business results that are most relevant and useful to the end user.

 Another example is a mouse trap. You have the board, the spring, the catch, and even the cheese. The cheese somehow is not usually mentioned. But maybe that's where the designer comes in. That's perfectly in harmony, and it makes perfect sense. And therefore, the business should understand that's why these components are there, why it's made the way it is, why it's assembled as it is, and how it's going to ship this way because it has to perform a very specific task. If it's not clearly communicated, then it's open to opinion, and when it's open to opinion, then it's anyone's game at that point. So, for me, it's really about how you irreducibly solve a problem in such a way that there's no room for miscommunication.

MB: Can you talk about the work you've done with 3M? Which I think is fascinating and involves both combining breakthroughs and optimizing technology that they were already developing.

TB: There are two sides to the 3M conversation. It was an opportunity for me to work with such an incredible brand. And we were asked to help insert 3M into what we call A&D space, or the architect and designer space, through lighting. How do we do that as product designers? How do we enter a business such as 3M that's not commonly known to be in this space in such a way that's going to help grow this opportunity?

MB: Designers and architects aren't thinking of 3M as a resource when they're designing a space.

TB: Correct. We needed to send a message, in a way, to the industry that 3M is here. My thinking was, how can we differentiate 3M from all other lighting businesses? We knew we had some of the greatest resources in the world. Most lighting is assembled. There are parts that you buy, typically from Asia, you put it into a nice box, shape, whatever you want to call it, a diffuser, and you style light into the environment. With 3M, you have the opportunity to control light. And that's fascinating.

So, what we did was create a product called Lightfalls, which uses 3M intellectual property around guiding light. And, using this technology, this film of theirs, combined with optical physics, we were able to light an environment in a way very similar to a mobile device where the light is being super efficiently pushed out to your eyes. Very little light is wasted. We're able to do that with architecture. So what that did was send a message to the industry that this is more than just decoration. This is true innovation. And that immediately put 3M front of mind. Then, of course, on the heels of that, we came up with a whole series of products that other designers contributed to as well. We were not the only ones there. That started to then drive the business attached to it.

MB: This is your field, not mine, Todd, so I have a thesis here: Product design culture, in my mind, tends to be additive. Features are kind of seen as representing innovation, as being things you can advertise. And the more features you can build into products, the better. With that first furniture design project that you did for Humanscale—task chairs—and they're called that because they look like work in a way—they've got levers and buttons, and they have all these features, all of which are like machines for sitting in. So the machine you're working with can kind of sandwich you and turn you into a machine, too. I think the chairs that you developed in response to that were about returning to a kind of more, as you said, domestic or homey idea of what it is just to sit and be with people. So, a lot of what you're doing has to do with de-productizing these products. It's simplicity, but it's also something else.

TB: That's a great observation. To your point, the task chairs that we do, I don't think it's important to you to know how to adjust your chair. My job, my role, is to be empathetic to this end user. They need to sit in this chair and work or lean back and take a phone call or whatever they want to do. However, most chairs in this space, in the task chair space, have levers, dials, and knobs to adjust depending on how much you weigh or how tall you are. There were so many variables the engineers decided to let the end user decide. The issue with that is that as turnover happens in companies, the chair's not made for you any longer. You sit in it, and you're wondering why your back's hurting two years from now. It's my job to

remove those barriers and to focus on what's really meaningful. So in the Humanscale example, through their engineers, they're able to remove the levers and remove the knobs and the tension controls and all the stuff that you don't know how to function anyway. Now, when you sit in our furniture, it adapts to you immediately. That's powerful. And it's really addressing an end user and their life and their needs, and not getting in the way and not adding functions. It's much harder to do things this way because it's easier to put a lever there. However, that's not what we're here for.

MB: Are there genres of products out there that you think are calling for the same sort of demystification process, the same sort of simplification?

TB: Yes, I think you could take it from Casper, the mattress company, all the way down. I think that's the new culture we're experiencing. It's everywhere you look. I love how you're phrasing it—design has become demystified.

MB: Are the clients you're working with getting this? Do you have to lead them? Do they lead you? How do you find your clients, and what makes a good client?

TB: I think the clients are slowly getting it, the ones we talk to. Of course, a lot we talk to do get it. But the ones that I find most interesting, in some ways, are the ones that are slowly starting to get it and curious about this shift. These are the ones who want to dip their toe in. And so, for us, we're there to help guide them down this path in finding what works for them, for their DNA, so to speak.

 For me, what makes a good client is one who is willing to accept shortcomings and be honest with themselves. A lot of the delivery we bring is not our opinion. We'll go out and find the audience's opinion of this particular company, and we'll hand it to them and say this is what your audience thinks of you. You normally don't get these types of reports—one that says, this is what your audience thinks. And that sheds a lot of truth and a lot of light on the reality. I think our best clients are the ones who can respond to that truth and not just assume business is as good as they think it is.

MB: Do you think about what happens to the things you make after you make them? I mean, thinking of our oceans full of stuff, every street corner has stuff. If you're making stuff, you're bearing some responsibility for that, aren't you?

TB: Absolutely. Again, we try to design things with the least amount of parts possible. We're always designing with material that we think is best

The future, at least where I'd like to see us arrive, is a place where design is truly folded into the thinking around businesses and how businesses approach the world.

—TB

for the environment. We're always trying to find ways of reducing the negative impact. But, there are ways of contributing positively to our environment beyond product design. In our new chair, we're doing with Humanscale, a lot of the plastic is ocean plastic.[4] We're trying to get as close as we can to what is a net positive product, which is nearly unheard of in our space.

MB: What do you think of these chairs we're sitting in right now?

TB: I think these chairs are perfect for a 35-minute conversation.

MB: Is there anything out there that... a genre that you haven't worked in yet that you are just dying to get into?

TB: Not so much genres, but I'm always looking to do things we've never done before. I think the future, at least where I'd like to see us arrive, is a place where design is truly folded into the thinking around businesses and how businesses approach the world. And how do we ultimately approach users and people like you and me? And how do businesses think about that? It's critical to have designers integrated because then we're not only thinking about you and me, or my mom and dad, we're asking, how does something get made? How does it get thrown away? How does it ship? What's the impact? We're thinking about all this because we know how to make these things. So, it's critical to link all of that together, and not just hand a designer a solution you think you need, and take it from the designer and hand it off to another team. So, my ideal evolution is to arrive at a broader view of how design engages with business.

The conversation was originally recorded at the Yale School of Management in May 2019 as part of The Design of Business course and podcast hosted by Michael Bierut.

ii.

Mickey Beyer-Clausen

Design as Innovation

178. Design as Innovation

Mickey Beyer-Clausen is a Danish-born, New York-based entrepreneur with a track record of building venture-backed, category-defining companies. Currently, Beyer-Clausen is the Co-founder and CEO of Timeshifter—the world's most advanced technology platform for controlling human circadian rhythms. In 2018, Timeshifter launched its first product—now the most downloaded and highest-rated jet lag app in the world. In 2024, Timeshifter launched its second product—a new app to help shift workers optimize their sleep, safety, health, and quality of life. Before Timeshifter, Beyer-Clausen co-founded several other businesses, including Trunk Archive and Ascio Technologies. He is also the Founder and Chairman of Happiness Foundation.

You know a product is working when people are talking about it and sharing it with friends and colleagues. Hitting that goal should always be the ambition.

— Mickey Beyer-Clausen

Todd Bracher: Do you think that founders are finally beginning to understand and appreciate design?

Mickey Beyer-Clausen: Not so long ago, consumers had very few ways to research products. Now, anyone can go online and find out what other people think about a product. How was their experience? How many stars are other consumers giving the product? With this increased transparency, if a product isn't great, it's going to fail. But many products that fail could have been successful had design been accounted for.

So, what constitutes a great product experience? This depends on the product, but what I know—and I also know you share this position, Todd—is that a great product is never just about color or aesthetics. It's about what is appropriate. A product needs to do more than meet people's expectations. You know a product is working when people are talking about it and sharing it with friends and colleagues. Hitting that goal should always be the ambition. At least, that's the starting point for me. Also, is the product novel and innovative? Is it meaningful? Does it make a difference? Does the world need it?

This is also why I'm always prioritizing product design over many other costs. I've seen how this decision converts into word-of-mouth, driven by people's excitement about the product. When you get something just right, the effects of great design are numerous.

You can spend 10 percent on your product and 90 percent on marketing, but after the marketing budget is spent, the product can't sustain itself because nobody's buying more of it or talking about it. Or, you can spend 90 percent on the product and 10 percent to push it over the edge, just enough to get it in front of enough people to get things moving. If those people love it, it's going to spread even without a large allocation of capital for marketing.

As you know, I'm from Denmark, and in Denmark, design has always been part of our DNA. Most appreciate simplicity and getting to the core of what makes a product amazing. It has taken longer for this type of thinking to be embraced in the United States and in other countries, though some companies like Apple and Tesla obviously have recognized the importance of design in their product development for some time.

TB: I agree. In Denmark, but also in many other countries, design has always been part of the DNA of companies. But with the success of Apple and Tesla, we have started to see a shift in the United States. Before their success, design was nearly always approached as something one added on after the fact. It wasn't integrated into the entire research and development process.

Designers are ambassadors for end users.

—TB

MBC: Yes, design was rarely considered as a strategic driver by the management or the board. It wasn't part of the conversation at top level at most companies.

TB: Exactly, but even today, many business leaders still see design as only representing the customer or the end user. Of course, designers do represent end users. Designers are ambassadors for end users. But you understand something that many other business leaders don't appreciate—the fact that designers also understand the limitations or constraints that exist within an organization and where there are hidden opportunities. I have always appreciated that you can see how to stitch these things—the operational and end user perspectives—together, which is essential if you want to successfully bring a product to market and ensure it's aligned with your organization's strategic objectives.

MBC: I agree, and even when a product doesn't fail, companies often invest too much effort, too many resources, and too much time attempting to make a product work. This is why there are huge benefits to getting it right from the start.

As a founder, one thing you're always told is that it's about the idea, the team, and the business model. But I think before any of that, there are two other factors.

First, there is timing. Timing may be more important than anything else. You might have a terrible product and a terrible team, but can still be successful if you get the timing right. On the flip side, you can have the best team and business model and a great product, but if your timing is off, you can still fail. Once you get past the timing part, I would argue that design becomes probably one of the most important aspects of any successful product launch.

Why? Let me take one step back before we get into that and go back to Apple for a moment. Design became such an important part of their DNA. It was about Steve Jobs's relationship with Jony Ive. It was their partnership—their one-on-one collaboration—that helped build Apple. Of course, everybody around them was highly talented and offered significant contributions as well, but these two had a special relationship. Steve had a clear vision, and Jony had the ability to translate that vision into design.

When I look at what I have done the past twenty years, I have always had a design partner. A designer should be part of any founding team. I am not talking about bringing in a designer to create a product. Design is so much more than that.

When you're launching a new product, it is important to be able to tell a story so people understand how the product works without being handed

A good designer is able to condense, translate, refine, and simplify all kinds of information so it ultimately turns into a relevant and intuitive product experience.

— Mickey Beyer-Clausen

a complicated manual. If a product requires a long explanation, it's not going to work because most people's attention span is almost equal to zero. So, how do you take care of them? How do you make a product intuitive? And how do you build a product that tells a consistent story? Having a great designer on your founding team will help you make critical product decisions early on and significantly increase the chances for success. Your customers are simply much more likely to love your product.

TB: Can you talk about how this design-centric approach to developing and launching new products has helped you launch Timeshifter?

MBC: As you know, we have embedded design as an integral part of our DNA and as a differentiator from the very beginning, and this quickly translated into our customers really appreciating—and in many cases loving—our products. However, in addition to prioritizing design, Timeshifter was also born with scientific integrity in its DNA, complicating matters.[5]

While the science has been absolutely essential for our foundation, you can't let it dictate the actual product design. If we didn't have a designer, it's highly likely Timeshifter's apps would include unnecessary or complicated features that most people wouldn't understand or value over a simpler and more user-friendly experience. Adding twenty options won't make it better when the average user will only use one or two. The goal of scientists is to conduct research to discover new knowledge and understand the world around us, but that doesn't make for a great product alone. Designers have the expertise to make assumptions about people's realities and what they want and need. A good designer is able to condense, translate, refine, and simplify all kinds of information so it ultimately turns into a relevant and intuitive product experience.

Consider the pre-adaptation feature part of Timeshifter's jet lag app. Basically, a few days before you leave for a trip, you might want to pre-adapt to the new time zone. A scientist might ask you exactly how many days in advance you would like to start pre-adapting. A designer, on the other hand, might question if a traveler is going to understand the consequences of choosing one day, two days, four days, or seven days. A scientist is equipped to understand the difference between starting the process four days versus one day in advance, but a traveler isn't, so why give the traveler multiple choices in the first place instead of just proposing the most effective and realistic option? Why ask users questions they can't easily answer? Again and again, I encounter products that expect too much of the end user. This is often the difference between a product that's completely unusable and one that delivers a great experience users love.

The technology you're delivering has
to be relatable, understandable, and usable.

—TB

TB: That's true, but with Timeshifter, you're not just delivering a product to users who want to feel acclimated to local time when they start a vacation. Timeshifter also has an app designed to help people manage changing shifts of shift workers. How do you account for these two different users?

MBC: True, you have people traveling, and you have people doing shifts. A lot of people who travel on a regular basis are quite tech-savvy. Among shift workers, we're encountering more people who aren't always as tech-savvy, if only because they don't spend all day on their devices. People who travel also only need Timeshifter when they travel once in a while. Shift workers need it every day and have different expectations than travelers. If we had created one app that could do everything, then I believe none of our users would have liked it because it would end up being way too generic and complex. That's why we chose to create two apps.

TB: What you're identifying is the importance of context, which is essential to me as a designer. If you don't take the context into account, there are ramifications. Timeshifter's users include shift workers, and naturally, that includes a lot of people working in high-stress professions, including emergency responders who have to be alert when at work. This has consequences for everyone. So, the technology you're delivering has to be relatable, understandable, and usable. When it is, you're not just offering people something they desperately need, but something they might actually use, and that holds the potential to positively impact everyone around them as well.

I want to stay focused on circadian science for a moment. You've built this highly effective app. Still, for a long time, we've also discussed designing a way to filter out light, which would add another layer of effectiveness to Timeshifter. But Timeshifter is not an eyewear company. Then, at one point in our conversations, we realized that, perhaps, we don't need to create a pair of glasses and only need to provide a way to filter light. That's when we thought, why don't we just make a filter and stop worrying about the frames, and came up with the idea to create frameless glasses, which are really just a cut sheet of polycarbonate that rolls up.

Throwing out the frame and focusing on the lens offers so many advantages. This roll-up lens is flexible and portable and costs pennies, so the barrier of entry is super low, which means you're more likely to end up with compliance. You're not asking anyone to invest several hundred dollars in a pair of glasses with special circadian lenses. But this solution also had other benefits. Roll-up frameless lenses are inexpensive, so you can give them away, but because they are a novelty, though one with a function, you also see people walking around with them and taking selfies. They're excited that they can use these things and share them. So, in this

case, focusing on what was needed rather than what was expected—getting focused on creating a lens and forgetting about the frame—immediately expanded the potential audience for Timeshifter and helped turn users into ambassadors for the product.

MBC: What you're doing here is connecting design to marketing. This is actually something that Nike has done well. At one point, they replaced some of their ads with an app for runners. The app created a lot more brand loyalty than their ad campaigns. People were already familiar with Nike, but while the ads created brand awareness, the app created something even more impactful—a community. It was so incredibly successful that other companies started to reallocate their advertising budgets. With Timeshifter, we started with an app. It works well, so people use it and recommend it. But then, we started to ask ourselves what else can we do to gain adoption. So, you pay twenty cents for a pair of roll-up lenses and give them away with a free trial to our app. That costs significantly less than paying for a single click on Google. It is a surprising and fun way to educate people. It is also another example of the connection between design and marketing.

TB: But the goal isn't to market a product but to help people solve real problems. When you do that, you can really gain traction for a business.

MBC: True, but typically, when design works well, it's because you have a design partner either in the company or someone you trust, like I trust you. You have to have a relationship with your designer, and it can't be a one-off thing. For me, it is an ongoing conversation that means constantly talking about what works and what doesn't work. I also think it is important to recognize that a product isn't finished after it's launched. You have to continue to refine it.

When you have a finished product, why stop? With Timeshifter, we have released numerous updates to continuously improve the experience based on feedback, scientific discoveries, and new ideas. When we released the second major version of our jet lag app, we had a 98 percent drop in customer support tickets the day after we launched the new version. Why? Because instead of adding customer support people to manage the increasing number of support tickets as a result of our growth, we decided our founders dealt with customer support to understand first-hand what was going on. Every time we discover a new problem, we just fix it. Most companies outsource their customer service, so the problems confronting users are never communicated back to developers and designers. That's a lost opportunity to make a great product.

190. Design as Innovation

TB: What we're leaning into here is the need for a feedback loop. This is something we've talked about before. Companies tend to build something, push it out into the world, and then look at the numbers. If it's not winning, they kill it. They don't even think to respond or adapt. But a physical product is a living thing. That's why companies that have a credible feedback loop are far more likely to succeed.

MBC: It is critical, and it is connected to something I'm just realizing. From a founder's perspective, there are often cases where something doesn't work in the beginning and may not work for years. This can be for a number of reasons. It can be the business model, it can be for the price, it can be the design, it can be because of bad timing, or any other number of reasons. Everybody says fail quickly. If it doesn't work, move on to the next thing right away. I'm in complete and utter disagreement with that sentiment. My view is that if there is a market, there is an opportunity. If there is, keep going unless you realize the timing is way off and probably won't be any good for too long.

Fifteen years ago, no one cared about sleep solutions. In fact, many were proud of sleeping little. Over the past few years, that's changed. Suddenly, people are much more interested in wellness, including how long and well they sleep. So, there are two factors. First, it's a matter of continuing on until you figure it out—that's the feedback loop. Second, it's about timing.

TB: Is there anything that can help founders build this feedback loop and at least understand when the timing is right to launch a specific product?

MBC: I'm not a designer, as you know, Todd. I just appreciate being around designers who are really, really good because I've learned they are the gatekeepers to success. I've already talked about how important it is for me as a founder to work with designers and not just on a one-off basis. But there is another way design informs my work.

As a founder, there are times when you're going to run into obstacles. For this reason, I find it incredibly important to be able to visualize how my product is going to look and work in the future. Seeing it and imagining people engaging with it and all the amazing ways the product might eventually be used helps me keep my motivation and focus. Being able to see where you're heading, even when things are tough, has enabled me to avoid the kind of burnout we often see in startups.

TB: That's interesting. That's beautiful. And it makes perfect sense. There's beauty in the ability to mock things up, visualize them, sleep on it, and come back later. There's also a beauty in the ability to put an idea in the back of your mind, keep learning, and return to it later.

MBC: Exactly, and why not just play with the future? In meditation, there is visualization. You visualize situations with the intent of improving your mental state. As a founder or CEO, it is also important to be able to visualize a hypothetical future that can get you excited.

TB: There is something amazing about modeling a future concept. Sometimes, I model things up quickly, just to visualize them, and then stick them up on the wall, and over time, start to fall in love with the concepts, even if they aren't yet scalable. But there is something to knowing that one day, it would be great to get there.

MBC: Of course, and even if something you've mocked up and doesn't go anywhere because the concept is too far in the future, that's fine because it has kept you going.

TB: I appreciate that you understand the holistic value of design and its impact on the business, but this brings us back to where this conversation started. Do most founders appreciate this connection? I'm not convinced, and I wonder if this is connected to the way design expertise is perceived or valued in the business domain. A lot of people still don't appreciate that designers are not vendors but rather expert practitioners. I like to use a doctor analogy here. You don't go to a physician because you've already diagnosed your problem and already come up with a solution. You don't show up to purchase a solution you already think you need. When people contract with a designer, however, this is often how they approach the relationship, which is unfortunate because they miss out on the opportunity to have an expert help identify their challenge, which they might not be able to see, and offer a sustainable solution.

MBC: You're right, and that's why we both agree that design isn't about colors or shapes. It is something that has to infuse your entire business model, your marketing, and the entire expression of the company. If you approach your design team like a vendor, you're not cultivating a relationship with them, and without the benefit of a dynamic relationship, you're never going to design the products that you truly want to put into the world—the products that meet the needs and exceed the expectations of your customers.

The conversation took place online in November 2023.

iii.

Byron Trotter

Design as Translation

200. Design as Translation

As a global design leader at 3M, Byron Trotter partners with multiple company-wide business leadership teams to set design direction and influence design strategies, making him a core member of the Front End Innovation team. During his career as an industrial designer, he has developed numerous high-performance products ranging from medical devices to air and water filtration, lighting, and consumer goods. In his most recent assignment preceding his current role managing 3M corporate projects, he led design for 3M's Architectural Markets business, focusing on the creative application of cutting-edge lighting and surface technologies within the interior design and architecture space. His passion for creating new design solutions that bring technology to life in innovative ways has led to industry recognition on a global scale with multiple design awards. Prior to joining 3M, Trotter earned a BFA in industrial design at the University of Wisconsin and later studied design at the University of Applied Sciences and Arts in Germany.

Design's fundamental function is to
represent the end user and ensure their needs
are being heard and met.

—TB

Todd Bracher: We worked together at 3M for several years, so one thing we share is the experience of helping a non-design group of stakeholders navigate and embrace design and find value in design, which isn't always easy.

Byron Trotter: True, but I think the design quotient is rising around the world. I don't know if this is tied to globalization, but it is becoming more commonplace. Design is a system and an idea that is now a go-to in many organizations. At 3M, they recognize that our customers, some of them technology companies, value design. But design can still mean so many different things to different people.

TB: One thing I see design doing is optimizing opportunities. We can go down a lot of different paths here, but I think design's fundamental function is to represent the end user and ensure their needs are being heard and met. In my experience, a lot of business leaders are still attempting to problem-solve without really understanding the culture of the customer. The designer's function is to communicate how to meet the customer in a way that is culturally relevant. This is sometimes about pricing, but it can be a lot of things. Designers also play a role in optimizing systems internally to, let's say, efficiently meet an opportunity. But that's also something often lost on leadership. Often, even the smartest business leaders don't understand what levers to pull to drive results. That is where the designer fits in.

BT: That's well captured, and it's similar to what I was saying. When you look at any company where design is embedded, there's a journey. It's about knowing when to strike and when to recognize that understanding might take more time. You also have to know how to connect with people who are not where you are yet in their understanding. You have to have that mindset, and that's one of the reasons I loved working with you. You had an arms-open, mind-open approach and were always willing to just let the right answer appear. That's something that you did really well.

TB: Thank you! But when I entered the collaboration with 3M, I initially felt like we could do anything. Then, reality sets in. Despite all their resources, there's still a timeline, a market, capabilities, resources, and IP, so you start doing all the mental math, and then you start to define what the result is going to be. In a way, you start to work within the constraints. That is why it was interesting working with you. I was coming in from the outside, but you were there and had an internal map. In a sense, you had a cheat sheet of how things work at 3M and who was there and how things function and so on. I think that was a great combination of strengths and speaks to why

204. Design as Translation

larger organizations often benefit from having designers working in-house and coming in from outside to consult on specific projects. On that note, what do you think about external designers, and why do you think 3M decided to work with an external designer when they already have their own design team?

BT: That's a great question. I think, for me personally, it was a desirable approach because sometimes we all need to check our own instincts. It's obviously fortunate that 3M understands the value of design enough to have me there, and this isn't true in all companies. But there are also people like yourself who have a gift for transcending constraints, which is also valuable.

TB: Maybe it is just about creating the conditions for success? Sometimes, of course, this means getting other stakeholders on board. Do you remember the physicist we worked with? Early in our collaboration, she was happy to support our work, but neither of us has a Ph.D. or can solve any equation of any shape or size as she can. We weren't speaking the same language, but as the project evolved, as we finished our first installation and started to get traction and see results, I remember her coming up to me with this big smile and a very kind apology to say, "You know, I didn't understand what you guys were really doing until now." I'll never forget that moment. She really came around to understand what we were doing.

BT: You're right. She saw me in the hallway after we hadn't seen each other in a while, and she gave me a big hug and said the same kind of thing. She told me that she can't look at anything else the same because of us. That's one of the big payouts of this work. She is a total convert. She understands quantum physics and all these other different capabilities. Now, she appreciates how design can support her work. Everyone has something different to bring to the table. Design may be different, though, because everyone is still figuring out what design can do.

TB: Absolutely. I also appreciate that you know how to spearhead a lot of that conversion work. You run a lot of defense and offense to help create a space for the business to grow. I also think that in large organizations, designers don't always get full credit for their impact. Design work isn't always visible to other stakeholders, in part because they often don't fully understand design, but unlike other areas of expertise, let's say physics, they might not even realize there is an entire area of knowledge they aren't seeing and understanding. Another critical function of any internal designer or external design consultant is to reduce risk for an organization. Would you agree?

There is incredible innovation in the lab,
but it is often a struggle to get things out of the lab
in a scalable way.

—TB

BT: Absolutely, but we do that in a somewhat different way than most other people who are concerned about risk in a business. We do that through understanding and empathy. We are always thinking about the customer— the person embracing the object to be developed. But when you have a mood or an outcome in mind, and you want the user to get to that place, it is possible to reverse engineer. So, we see an end result and then work to get users to this place. In a sense, we're looking at the destination and then trying to reverse how we got there, and again, while it might be fully visible to everyone, this is another way of reducing risk.

TB: True, but I still think there's a gap between science and engineering and the world. There is incredible innovation in the lab, but it is often a struggle to get things out of the lab in a scalable way. At 3M, there was amazing potential with some of the films we were using, such as those with 99-plus percent reflectivity.[6] But how do you leverage this type of IP?

BT: Let me share an example here, which goes back to 3M's history to when they were developing overhead projectors, which relied on a Fresnel lens. That lenticular lens was later developed into probably twenty other products. Identifying the multiple applications of certain materials and technologies is the type of work designers bring to an organization, and that's also the type of work I'm now doing as part of The Front End Innovation team at 3M. Here, my role is I'm looking ten years out, thinking about how markets work, what markets we are winning with right now, and where we can move to stay ahead.

TB: Do you think most business folks can see this potential? There are a lot of dots to connect to understand how a specific material or technology might be relevant in another decade.

BT: I think they are mostly doing what they are used to doing, but when you put design into the mix, it pushes people out of their comfort zone. We're looking at problems that the world has right now and asking ourselves, what can we do to address these problems? At 3M, we know that we have products that can reduce the carbon footprint, but what do we do with all these products? This is why I see designers as translators. We're like visual linguists. It's about taking the issue and the solution and making it approachable to humans. That's what we do every day. I think most business leaders know this, but they don't necessarily understand how it all works. They just know that it does work.

TB: That's a fair assessment. When I'm engaging with business leaders, I emphasize that design is contextually based thinking. I don't need

Think about tightening
a lens—adjusting it—to come into focus.
That's what we do as designers.

—Byron Trotter

them to understand everything, but I do need them to understand that if we go in one direction, that decision will affect all other aspects of a project. I need them to appreciate that one needs to balance all these elements, which, in turn, govern the result. I always illustrate that to leadership so they understand that it's all connected—you can't just make something because it looks cool. I also like to say that we're there to take abstraction out of the process. That's why I still think that it's up to the designer to learn the language of business rather than the other way around.

BT: I agree, but I also think when we were in design school, we learned to adapt. It's part of what you learn early on as a designer. You don't run with the first idea. You have to fill out a sketchbook of twenty ideas and then come back to it and push it further. When you're trained in that process, it teaches you not to get too comfortable. It teaches you to adapt and to be prepared to speak different languages. Whether it's business or science, designers have to speak multiple languages. You have to learn how to speak to other professionals' values and learn how to help them zoom out to see all the different components that we see. When we step far enough back, everything starts to pull together in the middle. And I think we're that lens. Think about tightening a lens—adjusting it—to come into focus. That's what we do as designers.

TB: I agree. We're that soundboard and that lens. But as you were saying, design gives you the ability to forecast—to see a prototype, understand it, and even anticipate how it will be adopted many years out.

BT: True, and I think seeing is believing. When everyone sees the same thing, and it becomes commonplace knowledge, then it's undeniable. What we are doing is visualizing how something could be different. A good example is shoes. We used to use leather, and it was a subtractive method of manufacturing. You had this leather hide that you cut into shapes, and then you connected them. Now, we have 3D stitching woven items that don't harm the earth nearly as much and help your feet breathe and, perhaps, help you run faster. Designers saw this possibility. But if you don't know how to build things in the physical world, you don't know how to do them in the mental world, so it's impossible to forecast what might come next without this expertise, and that is what we bring. Of course, you can't be irresponsible when you're thinking about what is possible. You have to think about how this is going to be produced. It has to be safe. Cost is an issue, too. And you have to balance beauty and function, as well as emotional needs and wants. Sometimes, it feels like all we do is balance things. You know what I'm saying?

Design gives you the ability to forecast—to see a prototype, understand it, and even anticipate how it will be adopted many years out.

—TB

TB: I do! So, while we're not physicists or engineers or business leaders, we are balancing the perspectives of all these folks and thinking about the needs of end users as well. We're also asking other experts to operate with excellence—to put their skin in the game—and when they do this, they start to get excited, which is how possibilities open up. So, what projects are you working on now that you're most excited about?

BT: We have a new product that's bio-based. To make a long story short, one of our scientists said, I have this film, what are your thoughts? We took the concept and did a lot of experiments to explore its potential. In that case, I was in the right place at the right time, and I was ready to catch the ball and run with it. We're very excited about the future when it comes to discoveries like this.

TB: Sometimes, there's a sandbox or a toolkit, and it is really just a matter of what you can build in that space and how fast you can do it. But Byron, as you know, the most effective designers also build things that are understandable and relatable. In some ways, that is the most important aspect of a designer's function.

BT: It's so important, and I don't think they emphasize this enough in design school. You're going to have some people who take your ideas and just clear the desk and want to get going. But more often than not, it is about relationship building, and again, this begins with learning how to speak to stakeholders in a way that they understand.

The conversation took place online in November 2023.

iv.

Fred Maxik

Design as Science

218. Design as Science

Fred Maxik has been the principal inventor on more than 400 patents. He has also been the recipient of the White House's Champion for Change Award, a Congressional Medal of Merit, and a NASA Achievement Award.

Design is an integral part of every technology.
Without design, the translation of
the technology often suffers considerably.

—Fred Maxik

Todd Bracher: Scientists are usually not seen as creatives—at least, it's not the first word that pops out—but I see the way you think as deeply creative. So many things you've done, you couldn't have done without a wildly creative mentality. So, I would like to start here. What are your thoughts on the role creativity plays in your work?

Fred Maxik: I think there are probably two pieces to that answer. The first part is from a science standpoint. Creative science is not necessarily translatable. It's not necessarily something everyone can comprehend. The language we speak is often very, very different than the language the general public speaks. So, we often find ourselves whispering to each other versus people at large. I also think there is a large piece of translation that's lost when you put scientists in the room. Design is just the opposite. Design is what makes things relatable. One of the reasons for the fanfare of design is that you create the language and the wonder. Even though the underlying science may be interesting, unless you find a way to create an environment that translates to a consumer or a user, you'll never convey that wonder. So, really think design is an integral part of every technology. Even things as technical as a particle accelerator are defined by design elements. Without design, the translation of the technology often suffers considerably.

TB: I agree, but I also see amazing design based on questionable science succeeding in the market and see great science, often with poor design, not succeeding in the market. Do you find this to be true as well? And, do you find that as a scientist, as an innovator, design is a critical component to help concepts reach their intended destination with efficacy?

FM: First of all, we have the most wonderful science, but we can't make that science comprehensible to the public, and it often fails. Unless you think about how a product will be used, felt, and touched and how it relates to a user, you often fail. You can come up with wonderful ideas, and they can fail. LED lighting is a good example. Some of those early light bulbs looked Frankensteinish. It wasn't until we got down to designs where they were really approachable and looked like something people had used before, seen before, and experienced before that they became widely acceptable. So, I think we've seen proof over and over again that unless you apply a design that has a very artistic and sensible approach to it to address the public and make it something that they can relate to, you've done too much new and with too much new, you're destined to end up speaking to a very narrow group of the public.

TB: Can you elaborate on your work with the LED, for example, in the early days? Where did it start, and what did you solve? Then, where did it go? Where and how did design eventually become part of that?

FM: The earliest of the LED designs we executed, which is going back twenty-five years ago, were built for highly functional units. All the elements associated with them made them functional but also ugly to a large degree. We thought as engineers and scientists that these elements were necessary to do the things we knew how to do and we needed to do, whether it was to cool the LED to transfer power or the emissions of light given certain spectral requirements. Those were the elements we thought needed to be there and be seen and visible. But it soon became clear that those were pretty darn ugly and unusual-looking fixtures. The acceptance of that was fairly narrow. There were also pricing considerations and other things that came over time. But, in general, when we would approach people who had just built a multimillion-dollar office building or parking garage, they would say, "Well, we understand that this will save us some money on energy, but we just can't swallow what this thing looks like that." So, that's a firsthand experience that unless you get something right, the audience is going to be pretty narrow, even if there are benefits they can recognize.

TB: The way I like to operate in design, of course, is to integrate the design earlier on. I'm not necessarily glued at your hip in the lab, but I'm spending enough time with you to understand where you're going and maybe even in a position to give feedback earlier from a design perspective that can help steer some of your work and, by extension, reduce the time it takes to make something look better or to make something more functional market acceptable later. Does that make sense?

FM: There is clearly a collaborative element to innovation, engineering, and design. And, unless you make use of that collaborative element early, you go back and have to redesign over and over again or re-engineer over and over again to accomplish what you want to accomplish. In an ideal situation, you both challenge each other, right? You want that input from the end user and the design world, and you want that to inform the functionality of the final product. But often, that creates engineering challenges that you may or may not be able to overcome, though the sooner you take this into account, the more likely you are to avoid the need to go back and re-engineer something. I'd also say the design world approaches problems with a lot more human insight than the engineering world does. There are ergonomic issues that need to be solved, and there are simply user issues that need to be solved. You don't need to get to this too early in the process

from a TRL (technology readiness level) perspective [7], but as it starts moving beyond being just a proof of a concept, design is very important to incorporate.

TB: That makes sense. There seems to be a sweet spot in the technological readiness level, right? On a scale of one to ten, nine or ten is also not a great time to involve design. That's too late.

FM: Yes, that is definitely too late in the game.

TB: Do you also feel that, from a business standpoint, a lot of science that is developed may be years away from being able to be put into a physical form or can't be? But can design also help us understand what won't fit into the world yet?

FM: As designers, you can't change a standard that's acceptable around the world. But there may be things that you can do. You could challenge the engineering to move to a different space. If you were a designer working in automotive, you may say, "Okay, here's how much space I have in this dashboard, but you've just told me you need twice the space on the dashboard to feature all the displays." At that point, you have to challenge the engineering—you have to challenge the science and technology to see if we can get to that point. To do this, you may have to challenge how a dashboard currently exhibits or embodies a technology. That challenge can move us to a different type of technology and may move us to a different way to approach the technology.

TB: That makes sense. To shift the conversation just slightly, I also want to ask you about patent portfolios. You have a very extensive patent portfolio, and I assume many of your colleagues and peers also have extensive portfolios. Not every patent goes out into the world, and patents also have various purposes. Do you have advice for companies that have, let's say, a fairly extensive patent portfolio about how they can either bring value to those patents by engaging designers or helping transact these patents by engaging designers?

FM: I think, in the past, dormant patents have often fallen into the hands of organizations that troll the patent world and try to create litigation. I'm not in favor of that practice. It is not a very positive building experience. I do think that there is room for a group, including engineers and designers, to look at portfolios that may be dormant or may be underutilized and, perhaps, come up with spinoff ideas or other abilities to monetize ideas around those portfolios. There are issues with that as well because if it's

The more dramatic and the more
forward-looking the project is, the earlier
I try to have design in the process.

—Fred Maxik

a company that's not already in that business, you also have to understand whether the company has the wherewithal. It is a more involved financial transaction, but there is potential in larger dormant portfolios.

TB: I agree, of course, and think designers have a role to play in this process. But with science, are there certain traits that you look for or want to find in a designer? And how do you find a designer? Do you think all designers are created equal? How do you see that from your side of things?

FM: I know that not all designers are created equal. That is true in anything related to art, including design. So, what you do is find people who have sensibilities that align with your worldview. I've always found if you find someone who has got a completely different set of sensibilities, as talented as they may be, you're at odds too early in the game to make it work. And, I think you have to find designers that want to speak the same type of language as well. Here, I mean language in the broad sense, so I'm not only referring to design language but philosophical language. They have to have the sensibility that says if we care about sustainability, whether that's for materials, for people, and whatever else, that they have the same sensitivities because, if not, there will be a conflict somewhere, and that conflict will usually show up in ways you don't expect.

TB: So, how do you find these people?

FM: I look at the work that's been done, look at the portfolios, and then spend time with the people and really get an understanding of who they are. Without that element, as good as the portfolio may be, it, it may not match.

TB: Once you find that person who aligns with your sensibilities, how do you integrate design into your process? How do you avoid making design an add-on or tack-on at the end of a process? At what point do you like to integrate design?

FM: There are projects that are simple enough that they're already within form factors and confines that are understood very well. The ergonomics is understood, so it is not a problem to bring design in toward the end of that process. But when a project involves a new technology or a new utilization of technologies, and you're creating new product categories, you want to integrate design as quickly as possible—in some cases, even before I start some of the engineering—to get an idea of what the flavor of what we're trying to incorporate and understand how it will

Design is the red thread,
so to speak, through the brand.

—TB

get embodied. So, the more dramatic and the more forward-looking the project is, the earlier I try to have design in the process.

TB: So, how do you see design differentiating, let's say, your solutions or your technologies?

FM: Well, there are two pieces here. One, we've covered already, and that is about the descriptive language that design brings to any project. The second piece, and perhaps, a more subtle one, is how you use design to continue to develop and enhance your brand equity. That is about having common elements. It is about how to make disparate products from disparate categories with common design elements so that when someone sees one of your products, they immediately know it is from your company. This is what builds creative value over a period of time.

TB: That makes sense to me. Design is the red thread, so to speak, through the brand. You take a brand like Dyson, which is a classic example. You can identify it a mile away. Same with Apple. These are classics now.

　　What I really appreciate about you is that you have this capability as a scientist, engineer, and business owner to understand and engage across the entire field. That is rare. When I reflect on the contributions you've made to the world, there's another layer too. There is an ethical element, one focused on sustainability, and a humanitarian element to your approach as well that, I think, informs the work that you do. You are not just solving math problems. You are effectively designing how a solution can exist in the world. And this brings us back to where and when design needs to enter the conversation.

　　In some ways, design is more about guiding and shepherding solutions than helping shape solutions. So, I'll ask again, where does the designer come in for you—at what point are you okay with them pushing back and saying, "You know, Fred, I think we need to go in this direction or think more about the market?" Also, when the feedback comes back toward the technology and the science, do you leave room for these conversations? What is your part in this process?

FM: I like to say that there is an interesting dynamic between gravity and gravitas. I think there is a clear demand signal that represents this critical mass that becomes gravity. But there's also a solemnness, and there's the importance that we have to get this right because if we get this right, we will actually help in ways that are profound. I think when you feel that way about what you're working on, you want other opinions—you want to hear things as early as possible in that process and take those comments, whether they be from users or designers, into account. You've got to be

230.　Design as Science

able to transcend your own ego so that you can make sure you've listened in such a way that you can create something that's a better product.

I would say in my career, there have been times when I thought I knew better, but I have now spent time with designers who I appreciate and, because of that, have come up with much better products and actually been able to create some of the changes in the world that I have wanted to accomplish.

TB: Beautiful, and that makes sense to me. I guess one of my last questions, then, is how do you recommend or promote design. Let's say you are a corporate scientist. How would you recommend that your organization integrate design? Also, on a related note, where does a designer sit relative to the lab and relative to the business folks in the organization?

FM: I think that's a tougher question because of the various organizational characteristics out there. There's no one-size-fits-all. I don't know that I'd have a designer in the research lab. But we would definitely have a designer in the engineering lab. So again, it goes back to our whole conversation about technology readiness. I think there's probably more interaction between the designer and the engineer than there is between the designer and the scientist, unless the science and engineering within the organization aren't integrated. But as you know, from my standpoint, once you get to the point where you've at least proved the concept, the quicker you can bring design into that process and the better off you're going to be. Still, it depends on how the organizational structure works.

You've interacted with many people, including my technology and science group for years and years now. What was your experience? There have been times when we've had a couple of engineering folks who are hostile to ideas coming from the design side. How do you navigate that?

TB: That's one of my favorite questions, by the way. So, the way that I look at design is I try to take abstraction out. If you are working with a designer and you don't understand why certain decisions are made, you've got the wrong designer. So, I see the role of the designer as someone who is really there to translate market requirements. That requirement could also be cultural, but it also happens on other levels. Of course, there are tangible considerations, including the cost, the size of the box, and so on. But we're also there to help translate the intangibles, which are, in a lot of ways, even more valuable when you are thinking about the physicality of an object and the business case. In a sense, we're there to make sure all the tangible and intangible considerations line up. So, when I enter, I'm always framing how to meet the other side, and that's why the decisions are made. I'm not guided by my opinion. Like any scientist or engineer,

I am guided by objective truths. When I have multiple potential truths, I know there's still more to discover. At the end of the day, I try to make it almost as mathematical as possible.

So, while we've met folks over the years who struggle with understanding why design is even part of the conversation, at the very end of the process, I usually still get the metaphorical hug saying thank you for helping me understand. I'm more of a conductor of all the forces trying to bring together a coherent result than someone dictating what happens. I'm also there to ensure that the business objectives don't get eclipsed by other concerns.

FM: Great! I look forward to challenging you more in the future!

TB: I welcome the challenge! But, of course, there are also unknowns in design, as in science and engineering. There's only so much we can forecast, and design is a forecasting effort. We're trying to predict how the things that scientists and engineers are developing might land in the world and, of course, working to ensure that happens in the best possible way for business and humanity.

The conversation took place online in January 2024.

v.

Tyler Norwood

Design as Investment Strategy

240. Design as Investment Strategy

Tyler Norwood is Managing Partner for venture capital firm Antler in the United States, where he oversees the firm's US growth and geographic expansion. Tyler joined Antler in 2017 as its fifth full-time employee and has been instrumental in launching and scaling the firm. Prior to joining Antler, Tyler was the Global Head of Business Development for Global Fashion Group (GFG), where he was in charge of launching a marketplace business model for GFG's companies across twenty-one different countries; he also assisted with the company's IPO in Frankfurt in 2017. Before GFG, Tyler was the Interim Head of Marketplace at Jabong, which he helped sell for $70 million in 2016, and Head of Marketplace Vietnam at Zalora, the largest fashion e-commerce company in Asia. Along the way, Tyler has also completed the Vietnam Marathon, Singapore Marathon, and Boulder Iron Man. Tyler is passionate about providing a better on-ramp to venture capital for founders who want to change the world and hands-on support for founders in the first six months of launching a new startup.

A lack of attention to design drives poor investment decisions in singular instances. Too often, firms are making investment decisions without any real design or thought behind these decisions.

—Tyler Norwood

Todd Bracher: This entire book is about the principles of design, or what I describe as design in context, and for me, this refers to everything that governs what businesses do, including how we operate and how we bring products and services to market. It's not just about product design. With that understanding of design in mind, do you agree that bringing design in earlier or more consistently holds the potential to help more startups succeed?

Tyler Norwood: That's a very pointed question and worth discussing. Why is so much money eviscerated in the investment world? I can talk about that topic in relation to private markets, especially early-stage venture, which is the hot, sexy art of private investing that everybody wants to do. But the second premise of that question asks how we can use design to improve outcomes and, in a sense, that's an even more important question. I actually talk about this a lot, and it's driven by a few things.

Most importantly, being an investor is about designing a portfolio strategy, though a lot of people don't fully understand how investors think about investing. Individuals, outside the investment domain, tend to think about the returns made by people who invested in, let's say, Airbnb versus WeWork. This isn't how investors think about investing. As an investor, you're actually much more concerned with building a portfolio. Ideally, you're applying design to portfolio construction, but this doesn't always happen. Anecdotally and personally, I believe that 75 to 80 percent of VCs have no portfolio design. They don't have a thesis. They are in it because it's cool. Right now, VC is a very high social status career. So, there's a portion of people who are pursuing it because of that and another portion who are pursuing it because they're intellectually curious about startups. But I actually think a very small portion of the VC world has any thoughtful design behind their portfolio construction methodology.

So, the success or failure of one individual investment is not what's important in investing. It's about building a portfolio, and you can have a portfolio where 75 percent of your investments fail, but you still create absolutely fantastic returns for your investors because you designed your portfolio to accommodate that loss rate. In venture capital, you're looking at anywhere from 50 to 75 percent loss rates in a portfolio. Again, from my perspective, a lack of attention to design drives poor investment decisions in singular instances. Too often, firms are making investment decisions without any real design or thought behind their decisions. In aggregate, this is dangerous because it creates very mimetic behavior across the industry. The way someone who doesn't work in venture capital sees this manifest is in hype cycles that happen very predictably over and over again. These hype cycles are partially driven by the media, which only has the capacity to talk about a select few things at a time, so when they latch

on to something, they create the illusion that this is the only exciting thing going on right now. That is why everything is currently AI but, a few years ago, everything was about blockchain.

This is how we end up with mimetic capital. It's mimetic because there is no first principle behind the portfolio—it is just people investing in things that they think other people think are going to be successful. Right now, we're obviously in a hype cycle focused on AI. Whether or not it ends up becoming a bubble depends on whether the underlying technology catches up to the financial hype cycle. Take OpenAI as an example. Anyone who invested in that company ten years ago is out on the third standard deviation in terms of portfolio design and conviction. Anyone who's investing in it now, eight or nine or ten years later is mimetic to that original first principle. That's why portfolio design is also about first principles. I don't care what other people think. My portfolio strategy is to look for investments that meet these specific criteria, regardless of anyone's else opinion.

TB: So, it's not just a game of mathematics. It's a nuanced understanding of the organization, capabilities, manufacturing, scale, distribution, and all the stuff that goes into the product and the business. This is a somewhat crude example, but it is the difference between the new investor who goes into the stock market and invests all their money on big fish versus the person who gets an advisor who can actually guide them through all the nuances of investing and help them see possibilities that may not be immediately visible or comprehensible to most people.

TN: That is why there is a huge burden in true venture capital to have very strong first-party conviction about things that you're generally going to get quite poor feedback on externally, especially early on. If I start to talk about what I think the world will look like in ten years, no one is going to believe me, right? But most humans are very bad at conceptualizing what the world will look like ten years out. Let's say we're having dinner, and we're talking about the war in the Middle East and inflation and the upcoming election, and I say, "Hey, Todd, none of that stuff matters because we're going to be living on Mars in a decade." You or someone else might think, who cares about Mars, but that won't necessarily stop me from investing in a company that is developing infrastructure for us to live on Mars. If I did this, of course, some people might view me as a zealot or accuse me of ignoring everything that is currently happening in the world. But that is why venture capital is really hard to conceptualize for most people. You have to be able to see beyond what is immediately in front of you. You also need to be able to look at the data and first principles and believe in what you think is going to happen next.

Designers are very comfortable with
iteration, with sketching possibilities, and they
are also freer than a lot of other experts,
including most investors, to think outside the box.
By default, that is what we do.

—TB

Remember, when Steve Jobs and Wozniak started building computers, everyone thought computers would be a hobby. No one could possibly imagine that every industry in the whole world would run on top of computers. In venture capital, you have the conviction to see and believe in possibilities before they manifest.

TB: I feel like you're saying there needs to be some form of pre-investment design—a way of understanding what to do before you do it. But usually, early on, designers aren't part of the conversation. Is there a future where design thinking is part of this process?

TN: I definitely think so. The world tends to lead with form, and you have to dig really hard to get down to the function. The way this manifests itself in startups is in absurd arguments, usually based entirely on opinions or assumptions. But as a founder, you actually have to spend time digging down to understand what people really want. I remind founders that no one really wants to inherit their assumptions on how a problem should be solved. I work with founders a lot on that. I remind them that they can't take what people say at face value. You have to actually dig down and explore underlying human drives and emotions. We know that everything people say they want is actually driven by a relatively small set of predictable needs that humans have, and as a founder, you need to understand what part of those needs you are pressing on. If it's B2B, it's less an emotional decision and more of a financial and functional decision, but again, you have to drill down and discover what problem is being solved. If you can understand what they need and solve it in a way that they didn't know was possible, you can really create magic.

TB: I agree, and that is why design is so important. Designers are very comfortable with iteration, with sketching possibilities, and they are also freer than a lot of other experts, including most investors, to think outside the box. By default, that is what we do.

TN: A hundred percent—if you look at design, just on the surface level, you might not appreciate this, but that is why design matters. Design is also how we can understand how people feel about products and how people feel they're being perceived by the outside world when they use products. Here, Tesla is a great example. The electric car industry got design wrong for a long time because at first, the industry assumed that the only thing that mattered was that the vehicle was battery powered. They missed the mark completely. A car is one of the most expensive conspicuous consumption items you can buy. So, sure, it serves a utility, but it's also a massive social status symbol. If a car doesn't look cool and drive fast, a lot of people won't

248. Design as Investment Strategy

buy it. But Tesla understood that a car is one of the most powerful ways to externally signal what class you belong to. They nailed that. In retrospect, it is no wonder that the Nissan Leaf didn't do well. Now, that's very obvious.

TB: If you ladder it up further, the question is also how do we address climate change and global warming? You might say that we need to electrify. But if you start to ladder down, this solution isn't just about vehicles. With a design thinking approach, you start to see all sorts of areas of manufacturing that could consider electrifying and have a clear and positive impact on the environment. In other words, you start to see other ways to distribute the technology that most people are currently just thinking about in relation to electric vehicles. So, from a design perspective, the electric vehicle industry isn't just about making better cars. The industry is actually far more meaningful.

TN: Exactly, but if you want to drive real change, it has to overlap with something that satisfies the sort of emotional wants and needs of whoever your customer base is. Tesla did this well because they sort of tricked everybody into driving electric cars by making them cool and fast and a social status symbol. But then you face conflicts. Tesla's social status will be diminished if they launch a $10,000 car. It is really interesting to see how powerful social signaling is in terms of consumer motivation. I would argue one of the most powerful drivers of consumer spending is what a product symbolizes in the external world where the consumer stands.

TB: In fact, the disruption is happening to the disruptor already, but Tesla is finding ways to get in front of that expanding market by investing in charging networks.

TN: They can also license their battery and license their autopilot technology to other brands. They can make their technology available across every car brand and benefit from it since most of those brands' target markets are a different social class, so it won't necessarily be competition.

TB: We can also bring this back to AI, which is bringing new opportunities by the minute. But will all those opportunities be realized, and are people going to have the foresight to invest in the right opportunities? I see a lot out there, and a lot of misplaced and underutilized resources. It's as if design has to sort of elbow its way into the room to stop this pattern.

TN: I agree with you. The only thing I would challenge here is that anywhere you feel like there is waste, in many cases, if you dig in, there is actually

Design in context is concerned with all the factors that influence targeted outcomes.

—TB

something very intentional happening. It's easy to see a set of incentives that encourage certain behaviors, and so, from a system design perspective, it's actually a very predictable outcome.

One example we all know about is the over-hiring in big tech. Many companies have 75 percent more headcount than they need to actually run their organizations efficiently. You could say that's poor design. Why hire so many people you don't really need? But if you dig a little bit deeper, there is another story here. Let's say you're Google. You produce multiple billions of dollars of free cash flow every year. You could just sit on that money and give 30 percent of it to the government, or you could spend it on things. If you're going to spend it, what could you spend it on? If you're already spending pretty much the maximum amount you can on innovation and billions of dollars driving secret projects that hopefully turn into something at some point in the future, what's left? One of the biggest existential threats to incumbent companies is talent, including talent at startups and future competitors. So, when you look at the incentive system, Google actually has every incentive in the world to spend a lot of their money on hiring people just to keep them inside the building regardless of whether they do anything productive. They are incentivized to over-hire to manage the competition. I'm not sure that is their explicit strategy, but it's a very predictable system outcome, and many big tech incumbents exhibit the same behavior.

TB: That's what I'm talking about when I talk about design in context. Design in context is concerned with all the factors that influence targeted outcomes. Of course, incentives are not just financial. If you think about any ecosystem, that ecosystem naturally encourages certain things to grow. So, design in context is about building a system that produces the best possible outcomes, whatever those outcomes may be.

TN: That's why an area that I think we need to massively upscale is incentive design. I'm always very frustrated at the lack of discussion around incentives and the implications that they have long-term on systems. This is most apparent in government. Because politicians are elected for a limited term, they tend to slap together policies that solve problems in the short term. But even a child could explain why the incentives they are putting in place are going to create really unwanted behaviors. Over time, we end up accumulating a lot of bad incentives, which get built into government and into corporate structures. I think about this every day at Antler. I think about it with our portfolio companies in terms of incentive design. One of the things I say over and over again, ad nauseam, and my team hates it when I say this, is that incentives always beat principles. Any system will always regress to incentives. No matter

252. Design as Investment Strategy

how many principles or rules you put in place, the incentives will end up driving what happens.

TB: But incentives aren't necessarily negative. It's possible to build positive incentives into a system.

TN: I think it's actually all relative. I don't necessarily think there are universal positive or negative incentives. It goes back to understanding the function before the form. So, first, you need to be able to articulate what you are actually trying to accomplish here, right? That's step one, which I think a lot of people skip over. Second, I think incentives are amoral. If we judge them at all, it should only be to ask whether or not they create the intended outcome over a long enough period of time. So, for me, the real challenge is how many rules you have to put in place to fight against the incentives pulling people away from what you want them to do.

When you talk about incentive design inside of a company, it's really complex. For example, if people see that they will get rewarded for playing politics or for taking credit for other people's work or being the loudest voice in the room, the behavior in the organization is always going to regress toward that behavior regardless of how many memos you write about that fact that that is not the sort of behavior that gets rewarded in your organization. This is because humans are very good at implicitly figuring out incentive systems. So, as a manager or as a CEO, or as anyone who's trying to drive groups of people into some sort of organized behavior, a good incentive is one that means you don't have to spend all your time regulating behavior. Ideally, the incentives drive the behavior that you want naturally. A bad incentive is one that fails and leads to coercion through rules. Incentive design addresses this challenge.

TB: Exactly, and that's my version of culture trumps strategy. Culture emerges from processes. You have to have a process that drives what you need the team to do, and that, in turn, forms the culture that drives your organization's outcomes. A lot of companies don't see it that way. So, to your point, when we think about organizational design, we still all too often think about an organizational chart. That's frustrating because there is a typical way of building an organization, but one size doesn't fit all. To achieve outcomes, you have to understand the objective of an organization. What is the culture that you want to foster?

TN: And a big cornerstone of culture is the implied incentives. A lot of people get obsessed with the explicit rules. They think they know their culture or have a culture because they wrote it down on a piece of paper, but again, humans are very good at figuring out what the implied

incentives of a system are. For example, there are many industries where disagreeableness is an implied incentive structure. Think about investment banking or law, specifically private law. Anyone who works in those industries knows that there's an implied incentive around being disagreeable. It is also worth pointing out that those industries tend to have a massive lack of representation by female employees. Why? Because females, in general, score an entire standard deviation lower on disagreeableness across the five big personality categories. So, again, the implied incentive systems end up reflecting actual data about those industries, no matter how many rules you create to build a more inclusive culture.

TB: So, we started by talking about the role design can play in helping investors build stronger portfolios. Then, we pivoted to talk about how design and what you aptly describe as incentive design can build stronger and, as you just mentioned, even more inclusive organizations. From where you stand as a partner at Antler, are there any other ways that design informs your work?

TN: You also need to be very thoughtful about how you design your organizational structure. What does a really hierarchical high-power distance organization look like versus a really flat, low-power distance organization look like? Does that serve what you want to accomplish as a company in terms of how you design what you're doing? From your portfolio strategy to culture to organization structure, design thinking is essential.

The conversation took place online in May 2024.

vi.

Kate Eichhorn

Design as Social Impact

Kate Eichhorn is a cultural critic who writes about the history and social impact of new and emerging technologies. She is the author of eight books, most recently Content *(The MIT Press, 2022) and* The End of Forgetting *(Harvard University Press, 2019). Her articles and reviews have also appeared in journals such as* WIRED, The MIT Technology Review, *and* Science. *She is a Professor of Culture and Media Studies at The New School in New York City.*

You can't solve a problem
at the expense of creating another.

—TB

Kate Eichhorn: I'll open this conversation by confessing that although I have worked adjacent to design experts for well over a decade now since I happen to work at a university with a globally recognized design school, I have often struggled to fully understand design, and particularly what my colleagues describe as design thinking. But one thing I've come to appreciate over time is that, like poetry, design is still profoundly misunderstood. When most people think about poetry, they automatically think about rhyming couplets and usually visualize a page poem and likely one where all the lines cling to the left margin, but if you know anything about poetry, this isn't what poetry is. It seems to me that design is also profoundly misunderstood by most people. When they think about design, they think about objects and, perhaps, think only about rarefied objects, but design is so much more.

Todd Bracher: You're right. Design continues to be misunderstood, which is why part of my work always entails educating clients, helping them understand that design isn't limited to product design and isn't simply about aesthetics. Ultimately, for me, design is about assembling a solution to meet a problem as effectively as possible. So, it doesn't have to refer to the construction of a physical object. It could be about systems, conditions, and an entire variety of things. I think it's that simple, and you can do that in a million different ways. If you want to take this a bit further and put it into a business context, good design is when the efficacy is close to a hundred percent. But that's quite hard to achieve. Let's say you have one hundred pieces in inventory. Why can't you sell every piece in inventory instantly? What's the inefficiency preventing you from achieving that goal? What's the barrier to achieving that goal?

KE: Is it fair to say then that the very best design is design that helps us arrive at a solution without creating any new problems in the world? And if so, is it really about striving for a pure solution versus the solution that also comes with consequences, whether it is a negative environmental impact or the unnecessary exploitation of a certain population's labor or any other undesirable impact?

TB: That is why I talk about design and context. Design in context needs to account for everything, including the environmental and social impacts. You can't solve a problem at the expense of creating another. But there's always a balance and a give and take, so nothing is 100 percent perfect. So, in a sense, what designers are doing is trying to get as close to that 100 percent as possible. That's the goal. I also see design as very mathematical. You're trying to arrive at an optimal solution. Of course,

even in nature, nothing's perfect. That's why we see so many mutations in nature. Those mutations can also be quite interesting.

KE: You said you can't solve a problem at the expense of creating another, which is so true, but how many contemporary designers are able to achieve this?

TB: It depends on the context and situation, but it often feels like an ever-receding goal.

KE: When have you come closest to achieving this goal?

TB: One example is our hand wash, which I refer to as light wash [8] because it uses far-UVC-light to inactivate airborne pathogens. This is an interesting example, especially in terms of the environmental impact. We know that hand sanitizer has a very negative environmental impact. Its production and distribution are not sustainable. Our light wash device uses some electricity but generates very little ozone. The device has to be manufactured, but we chose to make it out of recycled aluminum, so again, there is a limited impact. At the end of the day, it's still a device that lives in the world. Some parts of it are recyclable, and some won't be, but when I compare light wash's impact on the environment to the impact hand sanitizer has on the environment, light wash gets very close to offering a solution with few impacts. Since it uses light to sterilize your hands, it can replace the liquid and gel sanitizers that are in the world today, which are deeply offensive to the environment. They're transporting heavy bottles of chemicals around the world. So, there is a transport issue and, of course, the amount of water that's used in the manufacturing process, and there is the plastic bottle waste that comes along with relying on those sanitizers. The footprint is tremendous. While light wash still has some impact, it's almost negligible against what it's replacing.

KE: I know that you don't love talking about chairs, but you've designed many chairs, including some that not only have managed to avoid having an environmental impact but also had a positive health and social impact in ways that are quite surprising.

TB: I assume you're thinking about the task chair I designed for Humanscale. A task chair is a curious example. Task chairs are terrible for our environment because they're usually made up of fifty to seventy components, which means they're comprised of parts shipped in from around the world. Also, once they are assembled, they're hard to

disassemble. On top of this, tens of thousands of these chairs are sold and thrown away each year. So, in the office furniture industry, which is about an $18 billion industry, these chairs are clearly one of the biggest offenders.

So, working with Humanscale, we set out to make the world's most sustainable task chair. By doing that, we've created a chair that uses reclaimed aluminum. In fact, there is no heavy metal in the chair. Also, these chairs are made of fully recyclable material, including ocean-bound plastics. It's a knitted frame, so we're not wasting anything, which you do when you're cutting fabric. We went through the list and tried to make everything super-optimized. The result is a chair that actually does more good than harm to the environment. It actually cleans the environment just by existing. It's taking plastic out of the waterways, for example, to be put into the chair. So, the more the chair is sold—even when you account for the transport—the cleaner the environment actually gets. It's a kind of upside-down way to look at how typical manufacturing is done, and in this case, we've managed to do this in a product category, which is typically the most offensive for the environment.

KE: That's amazing, but just to pose a challenge, I have to ask, do we still need task chairs? With remote work, how many people are using task chairs?

TB: What's interesting about this particular task chair is it is also designed in such a way that doesn't have any of the traditional features you see on task chairs, including all the knobs, locks, dials, and levers—all of those components that most people don't know how to adjust because they are too complicated. In fact, most people in the workplace end up sitting in a chair that's not at all made for them, which leads to all sorts of back, neck, and shoulder injuries. The chair we've created has a different approach. This chair does away with all the knobs and levers and is replaced by your body weight. Anyone who sits in this chair at any time, no matter what their shape, size, or gender, is in the right chair because the chair instantly adapts to the person using it. But because the chair has been stripped of all the hardware we associated with ugly task chairs, it's also a chair that you can use in your home and in different settings. So, you're right. Most folks don't want a typical office chair anymore, but working on your sofa, if you're working remotely, isn't sustainable either. Having this type of chair, which actually looks softer and warmer and, in a sense, looks more like a home piece of furniture but also performs its function better, is optimal.

KE: But there is still another chapter to this story, which is about culture. I know that a lot of women complain about office chairs because if you're under a certain height, it can be difficult to find a chair that fits. This isn't just

270. Design as Social Impact

a matter of comfort and fit, though. Imagine if every time you came into your workplace, the furniture was reminding you that you literally don't quite fit in, so there is something about a chair that adjusts to anyone's size—whether you're shorter than average or larger than average or simply not average for any reason—that also has a social impact, which may be difficult to measure but isn't insignificant when you're talking about workplace cultures.

TB: You're absolutely right. The workplace has historically been skewed toward what suited men, and all sorts of assumptions have been made about the average man. Now, we're starting to see workplaces that finally look and feel and perform in a gender-neutral way. The furniture is slowly adapting to this expectation, but the ultimate goal is to create more hospitality-focused environments. Everyone still needs to be supported ergonomically, but as you pointed out, there is more to ergonomics than supporting people's postures.

KE: At the start of our conversation, I said design is profoundly misunderstood by the average person, but maybe that is because its impact is difficult to see at first glance and because design is inherently abstract.

TB: That sort of breaks my heart because I really don't think it's abstract at all. For me, design couldn't be any more analytical. I don't think the world cares about Todd's opinion. I think the world cares about what's truthful, what's accurate, what's meaningful, and what's right. To insert an opinion is just not relevant. So, when I look at design, when I consider design in context, it's not abstract. It is really about ensuring every component of the ecosystem is accounted for.
 Consider the design of a leaf, which sounds like a fun project. So, what should the leaf look like? What shape should it have? I think we would all agree that, in this case, it doesn't matter what Todd or any other designer thinks a leaf should look like. The leaf is going reflect the context in which it is taking shape, which includes the climate, the temperature, how much rainfall there is, what invasive species are present, and everything else about the context. So, in the end, the leaf is going to take shape, and it is not going to be about my choice. So, when I say that design isn't an abstract process, I'm saying that it's like the leaf—with design in context, nothing is arbitrary or based on mere opinion.

KE: I appreciate what you're saying, but perhaps I feel like design is still abstract because, for those of us who are not experts, it can initially be challenging to understand how all the parts fit together. But maybe everyone doesn't need to be able to fully understand how all the parts fit together. Maybe that is your job as a design expert?

Ideally, a design expert working in a large
organization is recognized as
the equivalent of an orchestra conductor.

—TB

TB: True, that ultimately is my job. In an organization, everyone is inputting ideas into the system because they're experts in their domains. Ideally, a design expert working in a large organization is recognized as the equivalent of an orchestra conductor. I'm not an expert in every domain. I'm there to collate, organize, and connect. I'm there to make sure everything is aligned.

KE: I like this analogy. A conductor isn't an expert on every instrument in the orchestra. Likewise, the clarinetist or violinist doesn't necessarily need to be an expert on how to bring everything together in the orchestra. So, you're really saying that when you go into a large organization, you don't see yourself sitting in the design section with the other designers but actually see yourself conducting all the individuals who are working in these different sections or, to put this back into a business vernacular, working in their units or divisions.

TB: That's right. But I'm also not replacing the CEO. You might even say that if I am the conductor, the CEO is the producer. I'm orchestrating the parts, but there is still someone overseeing the larger production. I'm there to understand senior leadership's goals and objectives. It could be the boardroom, it could be with senior leadership, or it could be a combination. It's my job to have a full understanding of the outcomes they want to achieve and to orchestrate all those parts. This is also why I always insist on working closely with leadership.

KE: I know that you are committed to applying design to real-world problems. So, just out of curiosity, I want to see how you might approach a problem I was reading about this morning in *The New York Times*. This has been the hottest and driest year ever in many parts of the world, so in national parks in Canada and the United States, in preparation for what is expected to be another devastating season of forest fires, forest management experts are destroying huge swaths of forests to create natural fire barriers. Reading about this practice, I couldn't help but wonder, is this really the only solution? Is the only way to save forests to intentionally remove trees? This struck me as so simplistic since all we are doing is creating a gap between different sections of forests. So, how would you go about approaching this problem, which is almost certainly a problem that is going to persist over the coming decades?

TB: Wow, initially, I would have no idea, but it is an interesting problem and one that urgently needs to be solved. Those are the kinds of problems where you first need to lock a few of us in a room—design experts and experts from other domains—and then see what we come out with.

The most effective solutions are timeless.

—TB

In fact, that's really important. I don't have just one team that I work with. I have a whole network of people I work with, and depending on the project, I often bring in other experts. You need the right experts in the room, and that changes depending on the problem you're trying to solve. Once you have the right people working on this problem, there will be so many questions that you need to ask. What's triggering these fires? Of course, if it's lightning, if it's natural, you need to weigh the harm versus the benefits. To go back to the current solution, which involves removing trees, I am also thinking about where and how that material can be useful elsewhere. Maybe it's not just about destruction?

KE: Your reaction to my question is interesting because when I was reading about this intervention, all I could only see the loss and massive destruction. By contrast, Todd, you saw something something very different. You immediately started to think about what might be done with the trees that are being cut down. Since we're always cutting down trees for wood and pulp and paper products anyway, I'm now wondering if part of the solution is to be more intentional about when and where trees are being harvested.

TB: Designers always need to be thinking about the entire journey. We've been talking about fire, so let's shift to a water analogy. Everyone needs to rehydrate, but how do you understand this journey? When does the user's journey of picking up water and drinking it begin? Is it when they fill up their glass or before that? And when does that journey end? Is it when they finish drinking the water or put the glass down or wash the glass and put it away? But this is also something a lot of companies still get wrong. They tend to look at the immediacy of the problem they're solving but forget about everything that comes before and after the problem they are trying to solve. They tend to have a very limited or narrow view of the journey.

KE: You said at the start of this conversation that design is about assembling a solution to meet a problem as effectively as possible. The problem is that most of the time, especially in large organizations, people seem to spend most of their time addressing symptoms and often don't even have their eye on real problems, let alone real solutions.

TB: That's right, which is why I promote outcome-based strategies. So, for example, rather than saying, "We're going to design this thing or market this thing," I'm always asking my clients to focus on the outcome they want to achieve. If you want to improve a situation, including a pressing environmental, humanitarian, or social situation, you have to understand what outcome you want to achieve. Is it a higher quality of life? A healthier

quality of life? Rather than focus on the thing that you're developing, you need to be focused on the outcome you're trying to achieve. Once you start to look at things this way, you start to build your organization to suit the outcome you're targeting. That's when you start to achieve true alignment.

KE: Is it fair to say that you're in the business of future-proofing, though I appreciate that there is nothing speculative about your work and methodology?

TB: In fact, I think the problems we're addressing and trying to solve tend not to be temporal. I actually see it the other way around. In some cases, current human problems can be solved by adopting the most ancient technology. And this isn't surprising because the most effective solutions are timeless.

The conversation took place online in May 2024.

Endnotes

1. Deborah Gage, "The Venture Capital Secret: 3 Out of 4 Start-Ups Fail," *Wall Street Journal*, September 20, 2012, https://www.wsj.com/articles/SB10000872396390443720204578004980476429190.

2. David Cooney et al., "Redesigning the Design Department," *McKinsey & Company*, April 27, 2022, https://www.mckinsey.com/capabilities/mckinsey-design/our-insights/redesigning-the-design-department.

3. Charles Darwin, *On the Origin of the Species*, Revised Edition (Oxford, United Kingdom of Great Britain and Northern Ireland: Oxford University Press, 2008).

4. Mark Wilson, "'World's most sustainable' office chair has 10 pounds of ocean plastic," *Fast Company*, April 19, 2022, https://www.fastcompany.com/90741654/worlds-most-sustainable-office-chair-has-10-pounds-of-ocean-plastic.

5. Timeshifter®, n.d., https://www.timeshifter.com.

6. 3M Architectural Markets and Studio O+A. "3M Architectural Markets and Studio O+a Showcase Dynamic New Surface Finishes and Design Lighting at NeoCon 2013." *NeoCon 2013*. 3M, June 4, 2013. https://multimedia.3m.com/mws/media/877335O/3mtm-architectural-markets-at-neocon-2013-press-release.pdf?fn=NeoCon2013_PressRelease_06072013.

7. Catherine G. Manning, Technology Readiness Levels, NASA (blog), September 27, 2023, https://www.nasa.gov/directorates/somd/space-communications-navigation-program/technology-readiness-levels.

8. Sarah Lynch, "This UVC hand sanitizer could radically change how we sterilize our hands," *Fast Company*, September 15, 2022, https://www.fastcompany.com/90767982/this-uvc-hand-sanitizer-could-radically-change-how-we-sterilize-our-hands.

About Todd Bracher

288. About Todd Bracher

Todd Bracher is known for his contributions to industrial design and his influential roles in executive advisory positions.

His educational foundation was laid at the Pratt Institute in New York, where he graduated with honors in Industrial Design in 1996. Following graduation, his quest for deeper design understanding led him to Europe, where, after winning a Fulbright Fellowship, he earned his Master of Fine Arts in interior and furniture design at the Danmarks Designskole in 2000.

Bracher's professional journey is marked by a rich tapestry of global experiences, having worked and studied in Copenhagen, Milan, London, and Paris before returning to his home city of New York in 2008. His design ethos, deeply rooted in the principles of functionality, simplicity, and cultural integration, has led to the creation of timeless pieces and earned him international acclaim and numerous awards, including the "World Changing Idea" award from Fast Company, IF Design, and several Red Dot Best of the Best Awards. His contextual design approach, which prioritizes the efficacy of finding solutions to meet the needs of businesses, markets, and humanity, has become a hallmark of his work, distinguishing him as a pioneer in the field.

Since returning to the United States, Bracher has collaborated with dozens of leading brands across a variety of sectors, including 3M, Herman Miller, Knoll, Humanscale, City of NY, Georg Jensen, and Issey Miyake. Through these partnerships, Bracher has contributed to the design of consumer products, brand strategies, and organizations, showcasing his versatility and commitment to design excellence. His ongoing roles as a fractional design officer highlight his capacity to guide brands toward strategic differentiation, blending design innovation with brand positioning.

Beyond his contributions to product design, Bracher's influence extends into the realm of design strategy and executive advisory roles. He has been a vocal advocate for the integration of design thinking into business strategy, recognizing the potential of design to drive innovation, sustainability, and positive change.

Todd Bracher Studio's services encapsulate the breadth of his expertise, offering strategic partnerships, product strategy, creative direction, and sustainability coaching, among others. Through Betterlab, he also collaborates with scientists and innovators to shape emerging research and foundational technologies into game-changing products and solutions designed to improve our lives in measurable ways.

As a designer who has consistently pushed the boundaries of traditional design, Bracher's work serves as a testament to the power of design in shaping the future of our built environment and the way we interact with the world around us.

Todd resides in NYC with his two boys, Ash and Adrian.

Ash and Adrian, may your passion align with your purpose.

—TB

Design in Context
Todd Bracher

Text: Todd Bracher
Editor: Kate Eichhorn
Dialogues: Michael Bierut, Mickey Beyer-Clausen, Byron Trotter,
Fred Maxik, Tyler Norwood, Kate Eichhorn
Proofreading: Sarah Schedler
Photography: Todd Bracher
Production: Henrik Nygren Design

Published by Compendium Editions
63 Flushing Avenue
Building 275 Suite 403
Brooklyn, New York, 11205
USA

www.compendium-editions.com

First Edition: 2024

Library of Congress Control Number: 2024912496
ISBN: 979-8-9903175-0-5

Made in the USA
Las Vegas, NV
28 November 2024

12774407R00173